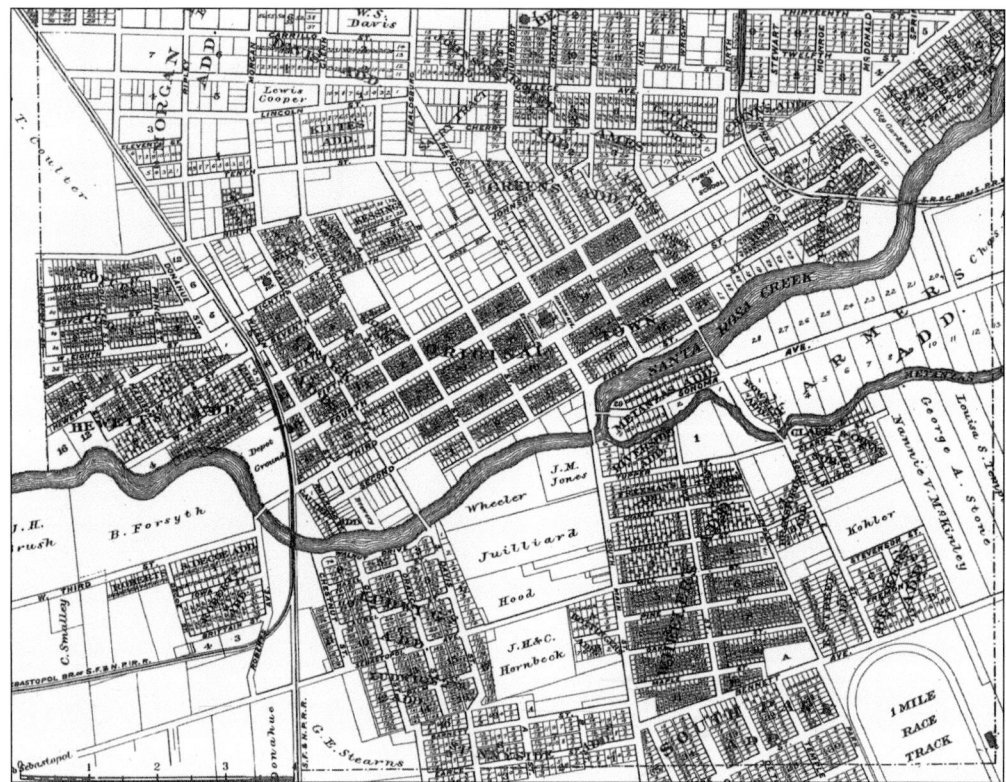

Santa Rosa Creek and its tributary Matanzas Creek are the obvious features on this map of Santa Rosa that appears in the *Illustrated Atlas Map of Sonoma County* by Reynolds and Proctor, 1898. The densely-built area in the center, north of the creek, is marked "Original Town." The racetrack at what is now the Sonoma County Fairgrounds is at lower right. The name "Juilliard" fills the land that is now Juilliard Park. Farther from downtown are various developments, known in those days as additions. The rail lines demonstrate Santa Rosa's position as a marketing hub. The Petaluma and Santa Rosa Electric Railway at lower left came from Sebastopol. The Northwestern Pacific (here labeled SF & NPRR) went roughly north/south. The Southern Pacific line arrived from Sonoma Valley, heading west and then north, terminating at North and Thirteenth Streets.

Simone Wilson

Copyright © 2004 by Simone Wilson
ISBN 978-0-7385-2885-4

Published by Arcadia Publishing
Charleston SC; Chicago, IL; Portsmouth NH; San Francisco, CA

Printed in the United States of America

Library of Congress Catalog Card Number: 2004104613

For all general information contact Arcadia Publishing at:
Telephone 843-853-2070
Fax 843-853-0044
E-mail sales@arcadiapublishing.com
For customer service and orders:
Toll-Free 1-888-313-2665

Visit us on the Internet at www.arcadiapublishing.com

Contents

Introduction		7
Acknowledgments and Further Reading		8
1.	Indians and Ranchos	9
2.	Crossroads of Wealth	15
3.	Cataclysm and Rebirth	31
4.	Harvest of Green, Harvest of Stone	49
5.	Merchants and Storefronts	57
6.	Civic Duty and a Portable Post Office	79
7.	The Call of War	93
8.	Whooping It Up	99
9.	Mad about the Movies	113
10.	Growing a Future	119

To Dennis Wheeler,
Santa Rosa Native,
Journalist, and Friend

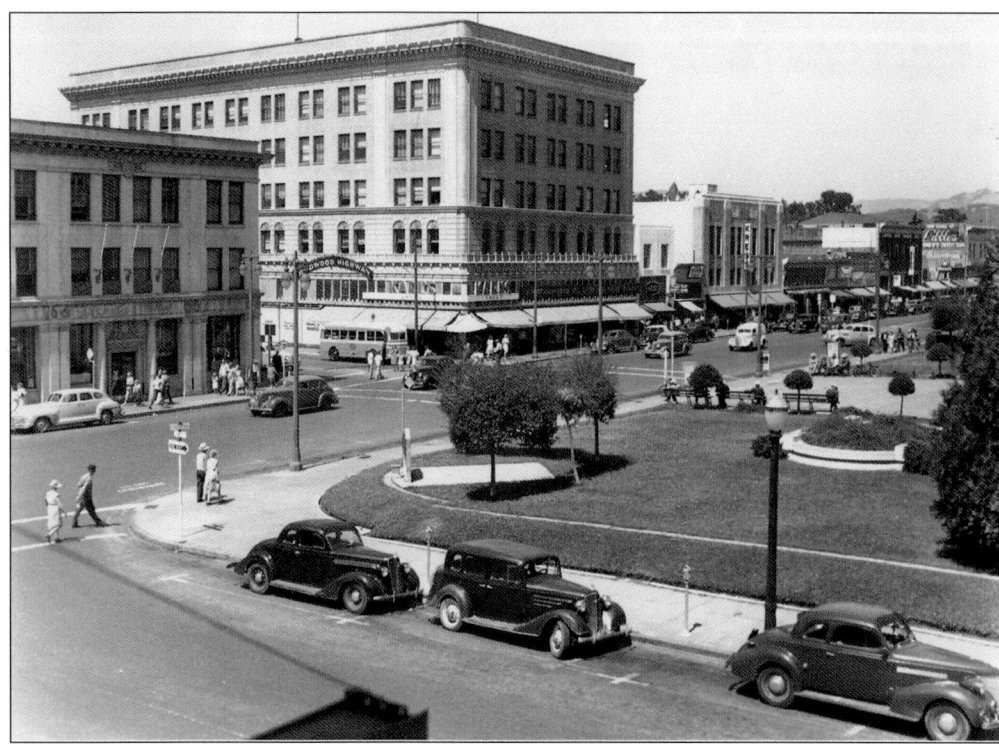

In 1941 Santa Rosa was a prosperous hub and the biggest California town north of San Francisco. This view, looking northeast from the Empire Building, shows a corner of Courthouse Square as well as Fourth Street with its shops. Note the Redwood Highway arch over Mendocino Avenue, between the Exchange Bank on the left and the Rosenberg Building. (Courtesy of the Sonoma County Museum.)

Introduction

Santa Rosa Valley was the traditional home of Pomo and Miwok Indians, who may have lived here for as long as 10,000 years before the first white settlers arrived in the 1830s. Their advent shattered the Native Americans' way of life. Settlers flooded in, starting ranches and fencing off the land.

Town building followed in the 1850s, and Santa Rosa, with its central location, became a commercial hub. As the county seat it was also the legal and financial nexus for the growing population of Sonoma County. Railroads arrived in the 1870s, bringing businessmen who would need restaurants and hotels. Stores opened to serve the farmers who came to town to deliver their produce. At the center of town a bustling commercial district developed with banks, furniture stores, livery stables, carriage makers, lawyers, doctors, and dentists.

In 1906 a quake along the San Andreas Fault destroyed much of downtown Santa Rosa. Townspeople were optimistic enough to rebuild a new town with wider streets, and practical enough to construct their new courthouse and other public buildings reinforced with steel.

Until World War II Santa Rosa, like neighboring Healdsburg and Petaluma, grew slowly, but in the late 1940s Santa Rosa's population took off. The town steadily outpaced its neighbors, adding new neighborhoods in all directions. Businesses once on the outskirts of town were surrounded by new neighborhoods and business districts. City leaders, trying to maintain Santa Rosa's historic identity in the 1980s and 1990s, created historic districts—Railroad Square, St. Rose, McDonald Avenue, Cherry Street—and even moved the town's massive post office two blocks to a new site so it could serve future generations as a history museum.

Like all communities, Santa Rosa grappled with the tensions and upheavals of the times. In 1962, for instance, the local black community staged a sit-in at the Silver Dollar Cafe, which had refused to serve them. Once a largely white town of a few thousand with small minority populations, the Santa Rosa of today is a town of 150,000 with a diverse population that reflects changes in the state as whole. People with Caucasian, black, Native American, Hispanic, Cambodian, Eritrean, Chinese, and Japanese ancestry and heritage share a region that was once home to a few thousand Pomo. Together they are creating Santa Rosa in the 21st century.

ACKNOWLEDGMENTS

I am very grateful to the libraries and museums that safeguard the collections of photographers who worked in and around Santa Rosa. These include the Sid Kurlander Collection and the Claude Sandborn Collection at the Sonoma County Museum; the Joseph J.H. Downing Collection at the Healdsburg Museum; and the Don Meacham Collection at the Sonoma County Library. These photographers left a legacy that enables us to visualize the town as it was in past eras.

Many thanks go to Joann Mitchell for the time and expertise she devoted to this project, and to Jim Mitchell, John and Gaye LeBaron, and Creighton Bell for helpful comments on the text. Thanks also to those who shared photos, including Karen McCarthy Price for the photo of her grandfather, Joe Coney; Mike Capitani for a photo of his grandfather, Peter Maroni; the Trione family; and Harrison Rued of the Pacific Coast Air Museum.

Thanks also to people I've interviewed over the years whose insights enhanced this book, including Tom Konicek, Hugh Codding, Gaye LeBaron, Gary Galeazzi, Enrico Traverso, Henry Trione, Foley Benson, Dayton Lummis, Joe Imwalle, Tom Gemetti, Sharon Saare, and many others. Thanks also to Eric Stanley and Roberta Harlan of the Sonoma County Museum; Dan Murley, Holly Hoods, and June Smith at the Healdsburg Museum; and Tony Hoskins and Katherine Rinehart at Sonoma County Library's History Annex.

FURTHER READING

The indispensable resource for Santa Rosa history is the two-volume *Santa Rosa—A Nineteenth Century Town* by Gaye LeBaron, Joann Mitchell, Dee Blackman, and Harvey Hansen (1985) and the companion volume, *Santa Rosa—A Twentieth Century Town* by Gaye LeBaron and Joann Mitchell (1993). Other useful works include *Santa Rosa in Vintage Postcards* by Bob and Kay Voliva, *Santa Rosa's Architectural Heritage* by Dan Peterson, *Sports Memories of Sonoma County* by Lee Torliatt, my own *Sonoma County—The River of Time*; *Wild Oats in Eden* by Harvey Hansen and Jeanne Thurlow Miller; and histories of the county by Ernest Finley, Honoria Tuomey, Tom Gregory, and Munro-Fraser. Many specific topics are explored in articles in *Sonoma Historian*, the quarterly of the Sonoma County Historical Society.

One

INDIANS AND RANCHOS

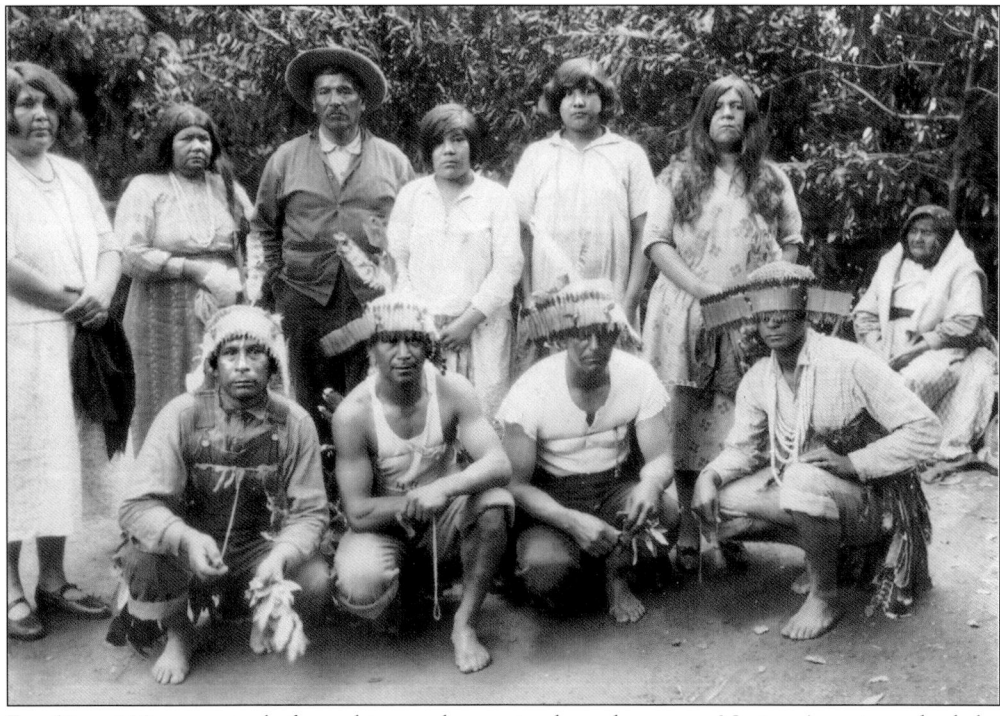

For 50 to 100 centuries before white settlers arrived on the scene, Native Americans had the land that we now call California to themselves. In the Santa Rosa area, the Pomos lived their lives in villages of 100 to 200 people, traveling short distances to gather items like willow for baskets or obsidian for arrow points. The advent of the Spanish and later U.S. settlers disrupted their way of life, and European diseases killed a large portion of the people themselves. Nevertheless, the Pomo still live among us as artists, professors, workers, and neighbors. These Pomos are from the Dry Creek area, north of Santa Rosa. In the back are Elizabeth Dollar, Maggie Woha, Jack Woha, Emma Lozinto, Ruth Cordova, and Lizzie Woha. In front, with Pomo regalia, are Henry Arnold, Manuel Cordova, Mike Cordova, and Alfred Elgin. Manuel Cordova was well known in the North Bay as one of the stars of the Indian Marathons, held in the 1920s along the newly-created Redwood Highway. (Courtesy of the Healdsburg Museum.)

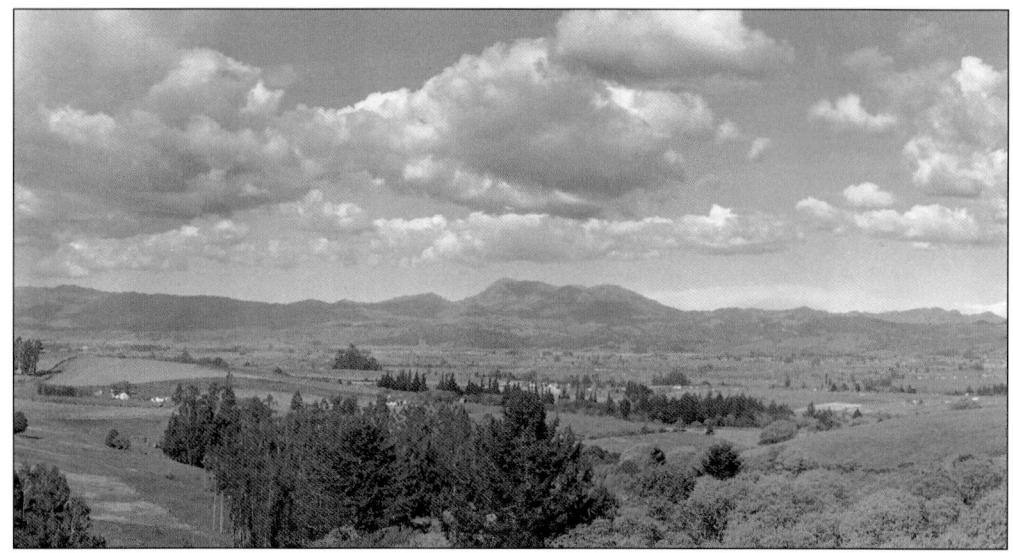

The Pomos, who arrived about 10,000 years ago, were the first people to inhabit the fertile Santa Rosa plain, shown here with Mt. St. Helena in the distance. The Pomo found a wealth of resources in the fertile valleys and hillsides, including game, acorns, and willow and sedge for their baskets. Various distinct Pomo groups inhabited the Santa Rosa Plain, Dry Creek Valley, the Clear Lake area, and the Sonoma coast north of the Russian River. Many of their descendants live in the area and maintain their heritage through support groups and tribal recognition. (Courtesy of the Sonoma County Museum.)

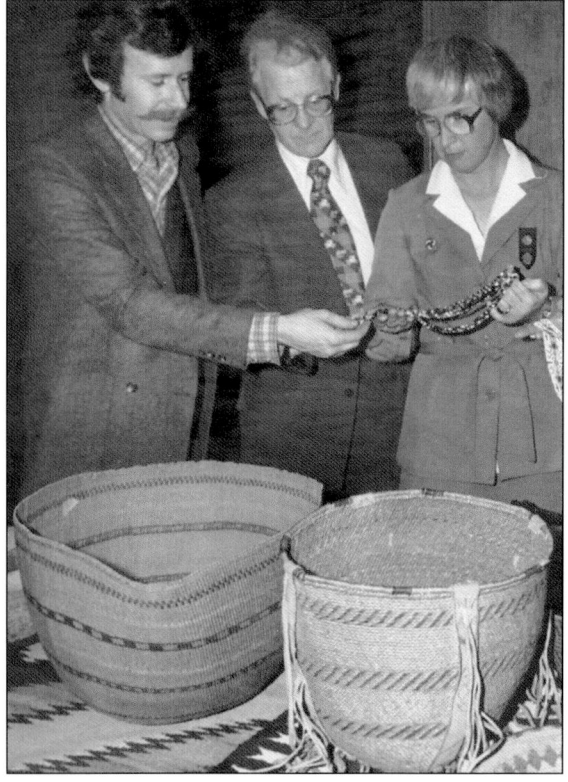

Pomo baskets are considered by many to be the finest baskets in the world. Several North Bay museums, including the Jesse Peter Museum at Santa Rosa Junior College, maintain basket collections. Prof. Foley Benson (far left), SRJC Pres. Roy Mikalson, and Barbara Phelps examine some of the Peter Museum's artifacts. Santa Rosan Jesse Peter was a naturalist and SRJC instructor who explored the American Southwest in the 1930s and collected ceramic artifacts. In 1975, his collection became the core of a Native American exhibit organized by instructor Bill Smith, a Dry Creek Pomo. In 1979, Benson, an SRJC anthropology instructor, organized the Jesse Peter Memorial Museum, which specializes in Native American life and multi-cultural studies. (Courtesy of Santa Rosa Junior College.)

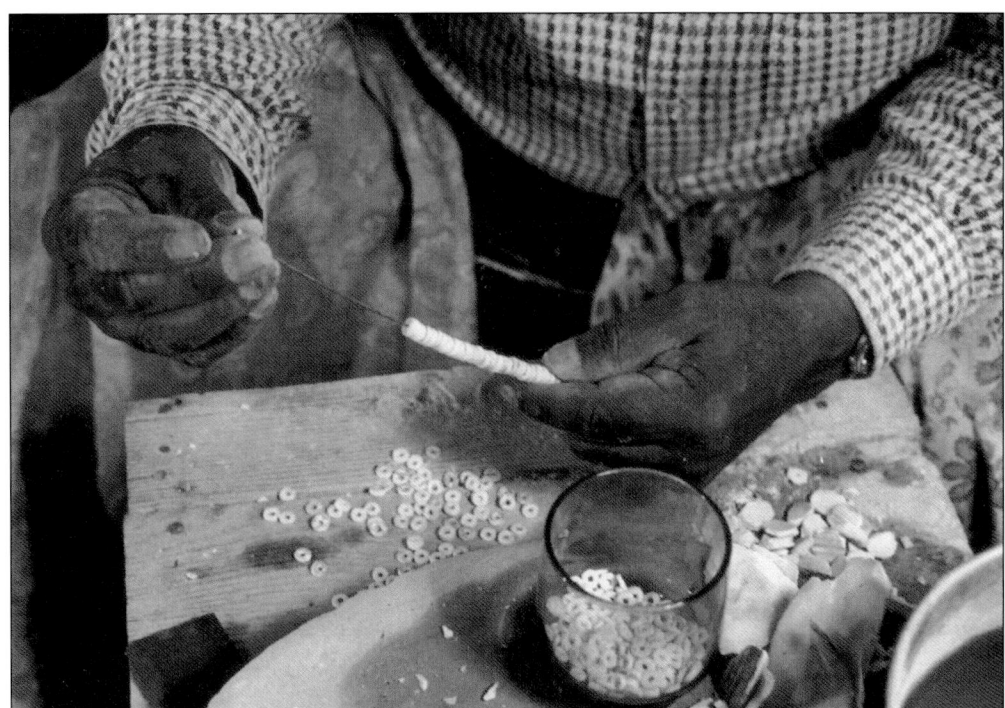

One of many traditional Pomo skills was making bead necklaces from shells. The artist first breaks up the shells into dime-sized pieces, then drills a whole in each piece. After threading the pieces on a stick or wire, he sands the entire roll, creating a string of polished disks. (Scott Patterson photo, courtesy of the Healdsburg Museum.)

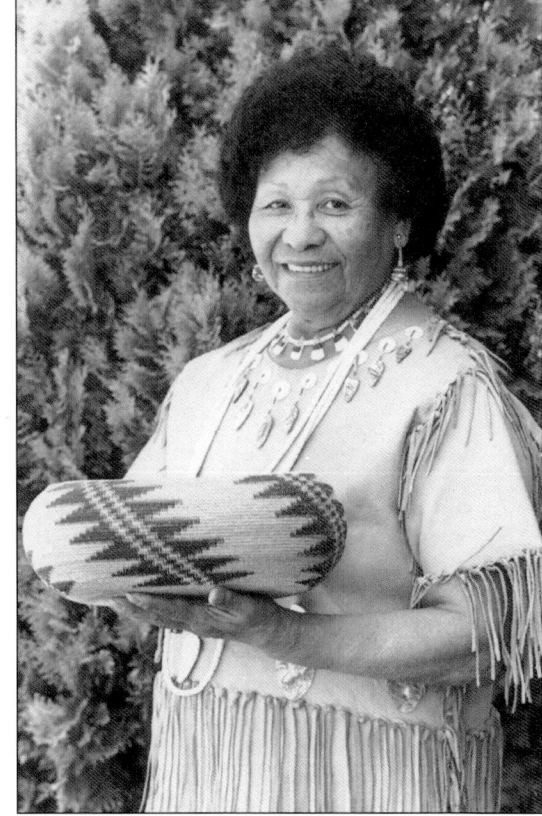

Mabel McKay (1907–1993), a member of the Dry Creek Pomo, was one of the most celebrated basketmakers in all of California. A tribal scholar and healer, she was both a consultant to anthropologists and a spiritual leader to her people. (Courtesy of the Sonoma County Library.)

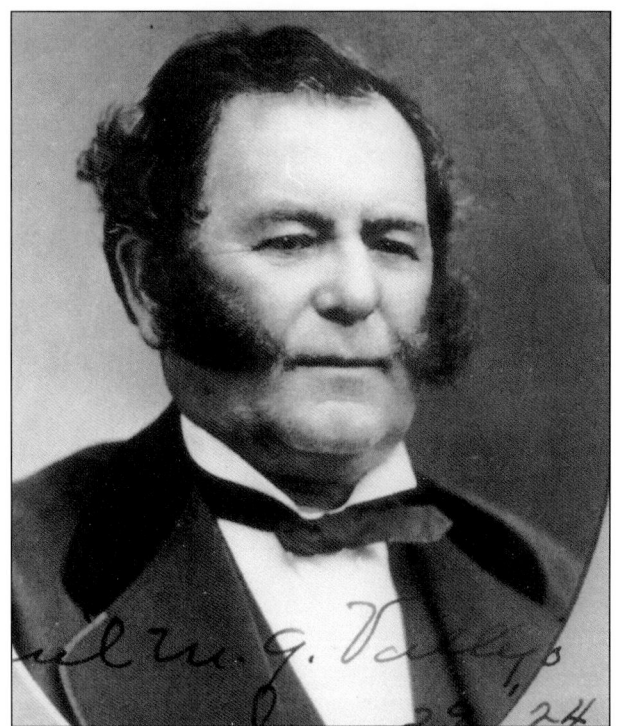

Gen. Mariano Guadalupe Vallejo was chosen by the Mexican government to solidify the country's hold on the northern frontier of Alta California. Vallejo divided much of what is now Sonoma County into ranchos. His own Petaluma rancho was 66,000 acres. He gave several of the ranchos to his family and in-laws, the Carrillos. The land that became Santa Rosa was the Rancho Cabeza de Santa Rosa, owned by his mother-in-law Doña María Carrillo. (Courtesy of the Sonoma County Library.)

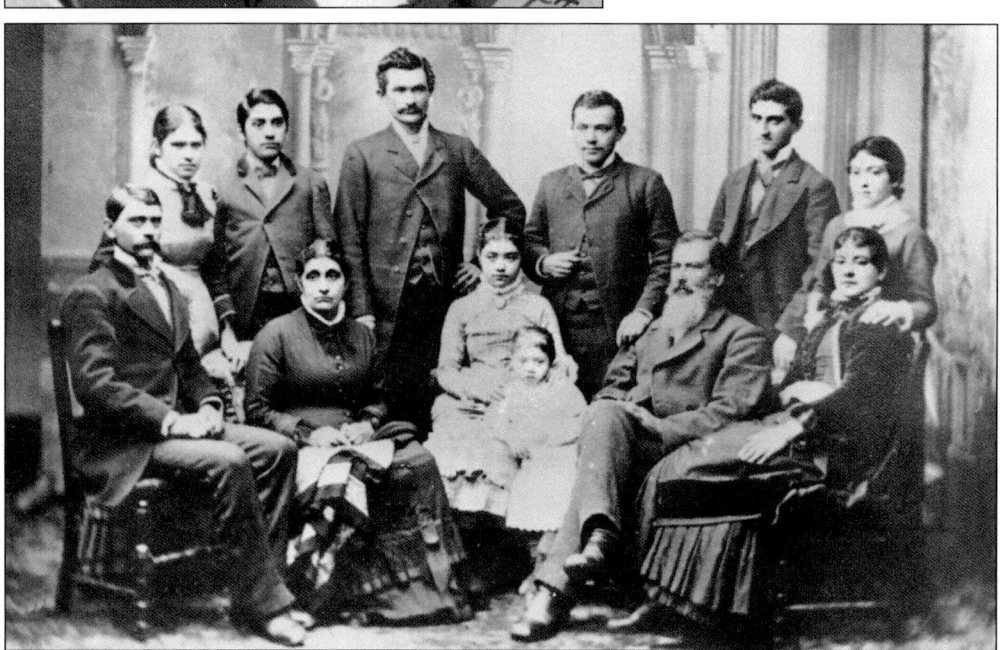

The Carrillo family in the 1880s included, from left to right, (standing) Nancy, Manuel, Albert, Eli, Mariano Avelardo, and Emma; (seated) John, Marta, Benecia, little Anita, Joaquin, and Rosario. The Carrillos prospered during the Mexican era. In 1846, after the United States took over, their ranchos, like the ranchos of many Mexican and Spanish grantees, were whittled down by protracted legal wrangling. (Burton Travis Collection, courtesy of the Sonoma County Museum.)

Doña María Carrillo's house, later known as the Carrillo Adobe (shown here in 1934), was the first white settler's home in Santa Rosa. Built in 1837, it was later a trading post, then part of the Hahman walnut and prune ranch, and finally the property of the Santa Rosa Catholic Diocese. The church agreed to sell the 14-acre site to developers in 2000. Negotiations are still under way to determine how to restore the historic adobe amid new residences. (Courtesy of the Sonoma County Library.)

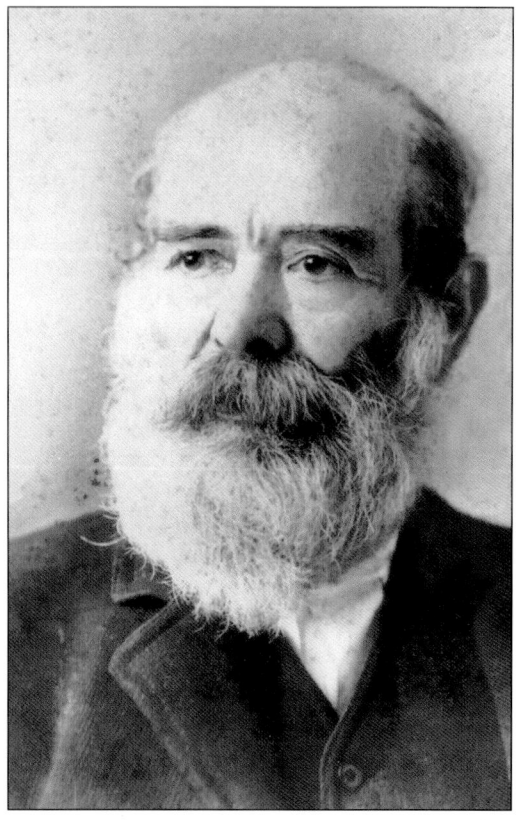

Julio Carrillo (1824–1889), pictured here in 1884, was the brother-in-law of Mariano Vallejo. When his mother, Doña María Carrillo, died in 1849, he inherited the land that would become the town of Santa Rosa. In 1853 Barney Hoen purchased 70 acres from Julio. Forty-niners Hoen and Ted Hahman are often credited as the founders of Santa Rosa, but it was Hoen and Carrillo who together laid out a grid for the new town, with streets A through E running north south, perpendicular to First through Fifth Streets. Generous to a fault, Julio donated half the land for the central plaza, gave land to churches, and sold other lots for a few dollars. When open-handedness reduced him to poverty, the City granted him a life-time job as the courthouse janitor. He is buried at the Rural Cemetery. (Courtesy of the Sonoma County Library.)

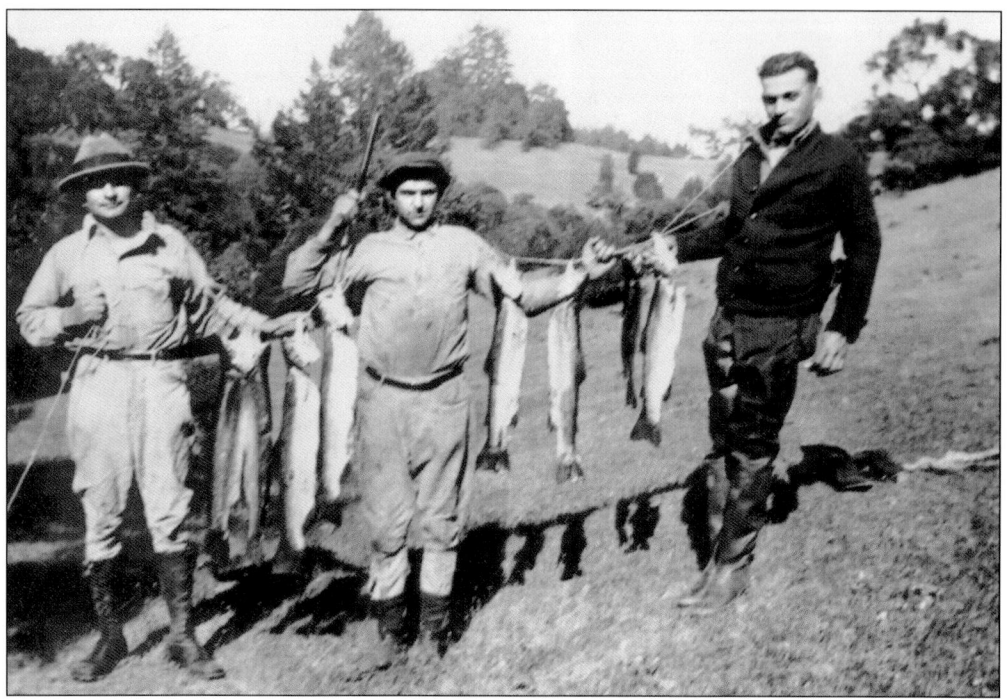
Joe Violetti, William Rossi, and Dick Violetti went fishing near Cazadero in 1922. The Violettis owned the Santa Rosa Hudson and Packard auto dealership. Santa Rosans often went to the Russian River to hunt and fish, going by train early in the 20th century and later by car when the railroad tracks to Guerneville were pulled up in the 1930s. (Courtesy of the Sonoma County Museum.)

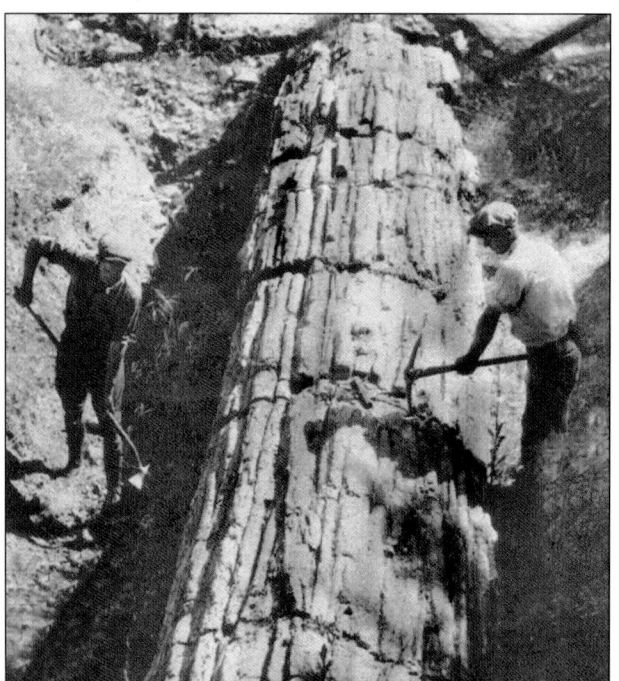

The Petrified Forest, one of the great tourist draws of the late 19th century, was created several million years ago by a volcanic blast that knocked the trees flat and then covered them with ash and mud. The proprietor of this early roadside attraction, known as "Petrified Charlie" Evans, charged 50¢ admission, according to Robert Louis Stevenson's memoir *Silverado Squatters*. You can still see this natural wonder—for a somewhat higher admission price—on Calistoga Road near the Napa County line. (Courtesy of International Newsreel Photos.)

Two

CROSSROADS OF WEALTH

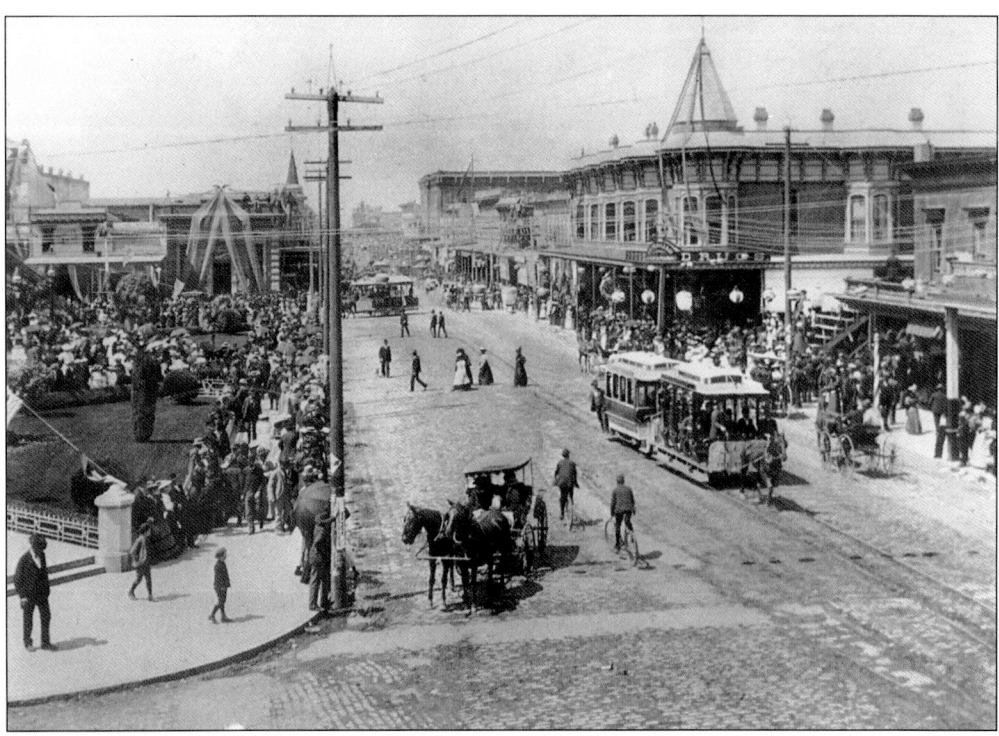

In the second half of the 19th century, Santa Rosa grew into a transport hub and the county seat with streets, stately banks, two railroad stations, prosperous stores, and neighborhoods of homes ranging from magnificent Victorians to more modest one-story dwellings. At its center was the spacious central square with its courthouse. This 1889 view is of downtown Santa Rosa, looking west along Fourth Street, with Courthouse Square on the left. Decorations are probably for the Fourth of July. Note the streetcar going down the middle of Fourth Street, as well as horse-drawn buggies and bicycles. (Courtesy of the Sonoma County Library.)

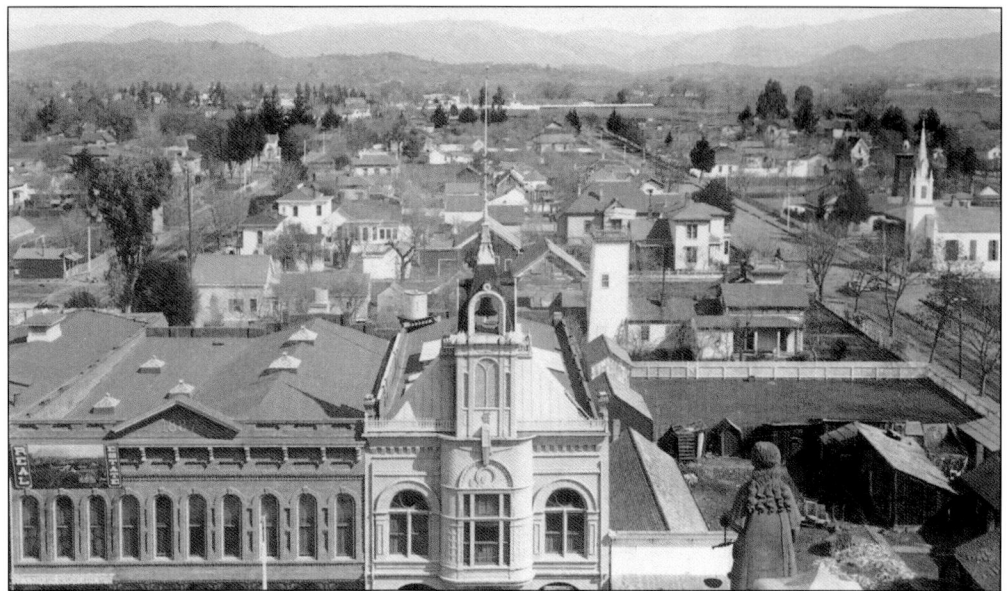

This view from atop the 1885 county courthouse shows Santa Rosa's 1884 City Hall at center, across the street on Hinton Avenue. Behind it is eastern Santa Rosa between Third and Fourth Streets, with the Mayacamas Mountains in the distance. The statue in the foreground, Justice with her scales, was one of four representing civic virtues, including Thrift and Industry. Hinton Avenue was named for Gen. Otho Hinton, an attorney from Maryland who donated time and money to beautifying the town square. (J.K. Piggott photo, courtesy of the Sonoma County Museum.)

Sonoma, the first town founded in the area, served as the first county seat. In 1854 newly established Santa Rosa vied for the privilege after holding a lavish barbecue to impress potential voters. Following the vote—716 for Santa Rosa versus 563 for Sonoma—Santa Rosa became the new venue for court cases and other legal matters. Luda V. Barham, at left, born into the pioneer Fulkerson family, was the first woman in Sonoma County admitted to the state bar in an era when women in many states were not even allowed to vote. Her husband, Edward C. Barham, also an attorney, was the son of John Barham, congressman for the district. Luda and Edward Barham practiced law together for many years. She died in 1895, aged 75. (Courtesy of the Sonoma County Museum.)

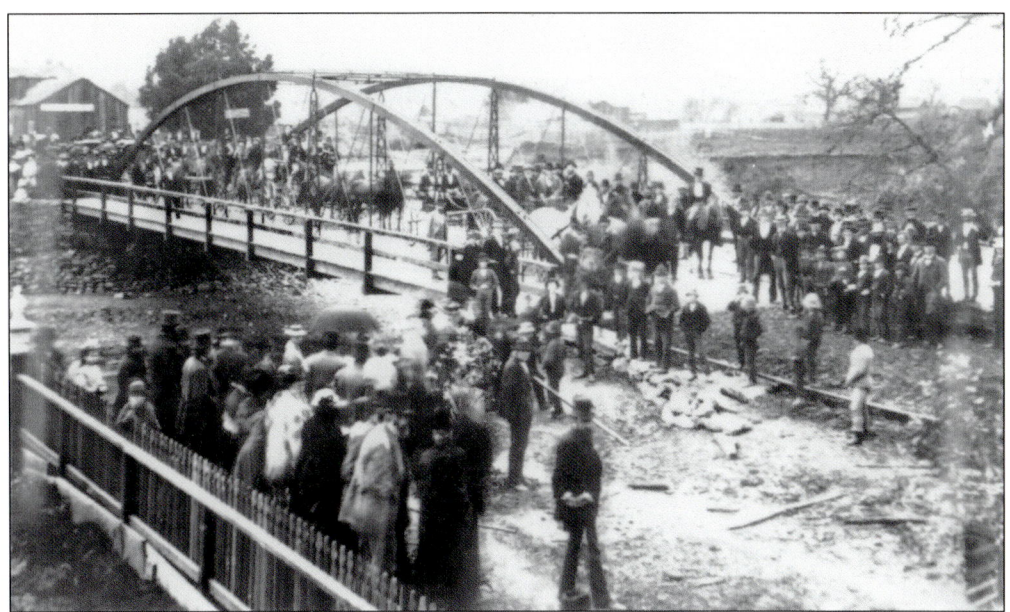

Santa Rosa Avenue's iron bridge across Santa Rosa Creek opened in 1876, providing a sturdy alternative to the wooden E Street crossing, which had fallen apart. Considering the onlookers and the procession crossing the span, this photo may have been taken on opening day. Several citizens held umbrellas against the rain. (J.H. Downing photo, courtesy of the Healdsburg Museum.)

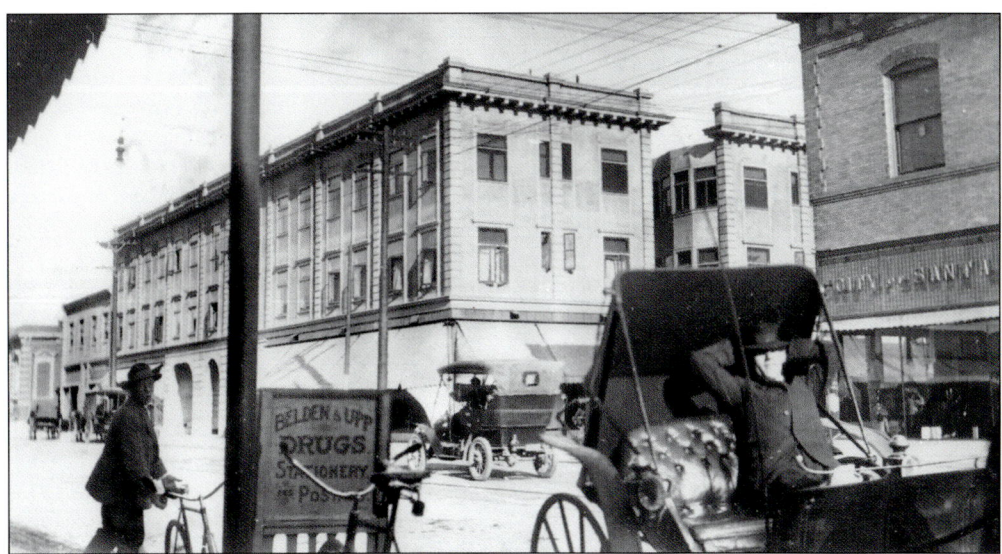

Downtown traffic c. 1900 was an eclectic mix of bicycles, carriages, and primitive automobiles. The driver on the right enjoyed the cushy upholstery on his buggy to take a snooze. At left is the sign for Belden and Upp's Drugs. (Courtesy of the Sonoma County Museum.)

The Occidental Hotel prior to 1906 was a two-story building with a wrap-around veranda located at Fourth and B Streets. On the ground floor were Jack Woodward's cigar store, the hotel lobby and bar, Charley Sterns bootblack shop, and Frasier's barber shop. The hotel was one of three that collapsed in the 1906 quake, accounting for the majority of the deaths in Santa Rosa that day. (Courtesy of the Sonoma County Museum.)

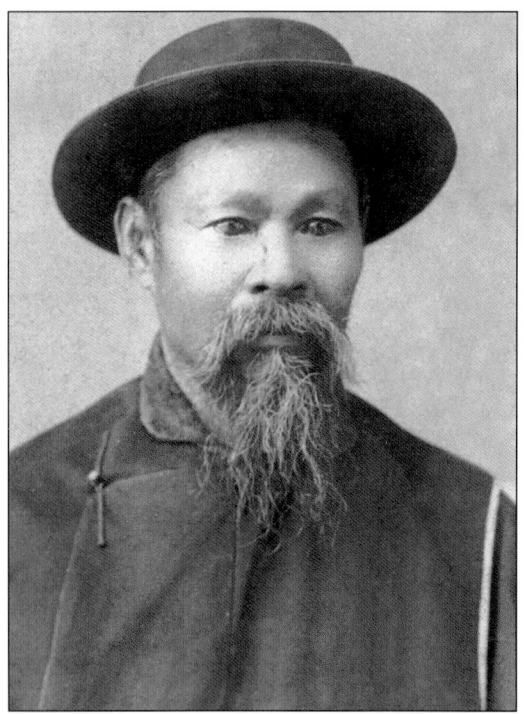

Chinese resident Sam Lam worked at Meng Hing and Company on Second Street. Like many California towns, Santa Rosa had its Chinese district, with a population of about 125 by 1880. It was concentrated along Second Street but gradually expanded until it reached the town square. White citizens, apparently feeling threatened, removed them from the town center in 1884 by evicting Chinese owners and building a new City Hall on the Hinton Avenue site. In 1886, at the height of a statewide anti-Chinese movement, editors of local papers, Thomas Thompson of the *Sonoma County Democrat* and J.W. Ragsdale of the *Republican*, firmly supported anti-Chinese boycotts. The local Chinatown shrank but did not vanish entirely, since local farmers needed their labor. (Courtesy of the National Archives.)

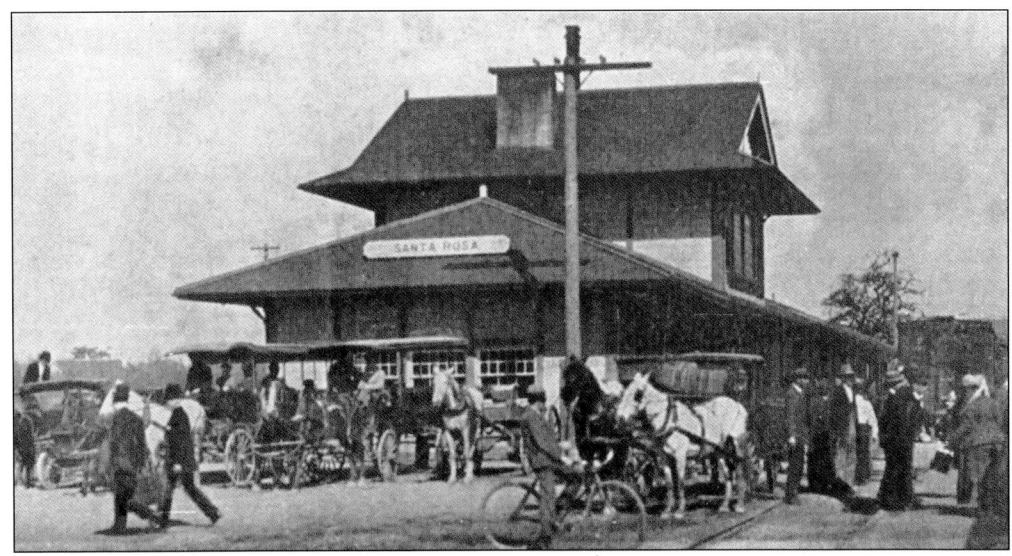

In 1887 the Southern Pacific (SP) and Carquinez Railroad built a line through Sonoma Valley; the Santa Rosa terminus was the SP station at North and Thirteenth Streets. Fruit broker Mark McDonald was one of the line's chief promoters as the line enabled him to ship produce to wider markets via SP's rail network. Trains also stopped at Annadel and Melitta Stations for quarried stone. Ironically, one of the buildings built from that stone after the 1906 quake was the depot of SP's main rival, Northwestern Pacific (NWP). The NWP Depot is now the Visitor Center in Railroad Square. The SP depot burned down in 1932. (Burton Travis Collection, courtesy of the Sonoma County Museum.)

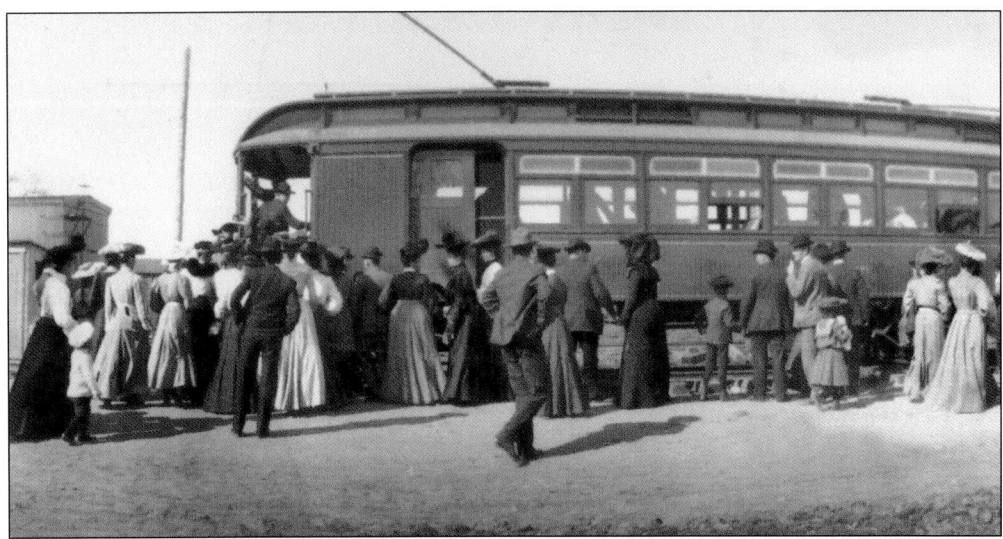

Passengers hop aboard the Petaluma and Santa Rosa Electric Railway. The P&SR, established in 1905, linked Petaluma with Sebastopol. Branch lines ran from Sebastopol to Forestville and to Santa Rosa. The P&SR brought not only West County produce but also students who attended high school and college in Santa Rosa. (Courtesy of the Sonoma County Museum.)

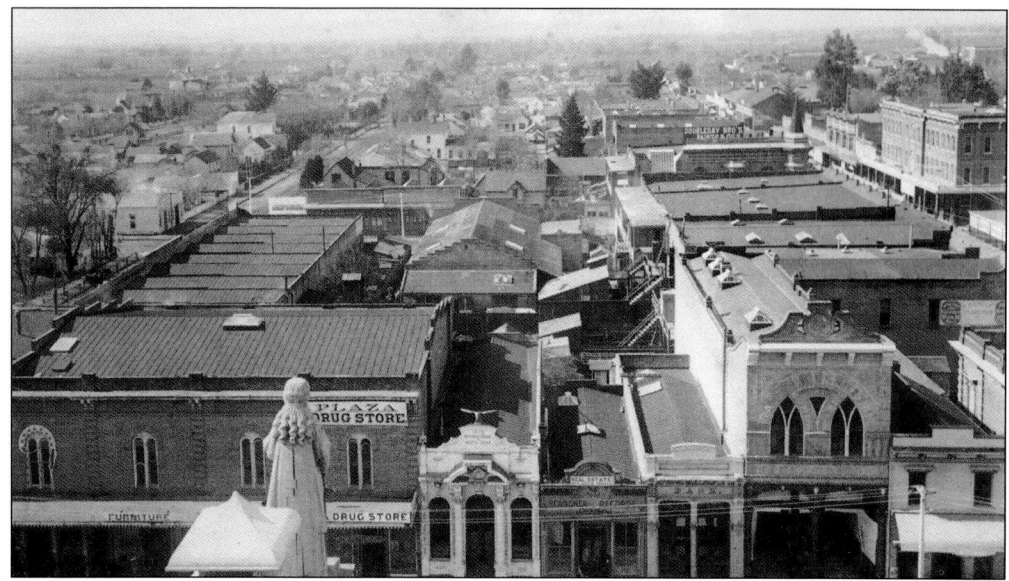

This view looking west from the county courthouse shows Third Street on the left. In the foreground is Exchange Avenue, Santa Rosa's financial district. (Courtesy of the Sonoma County Museum.)

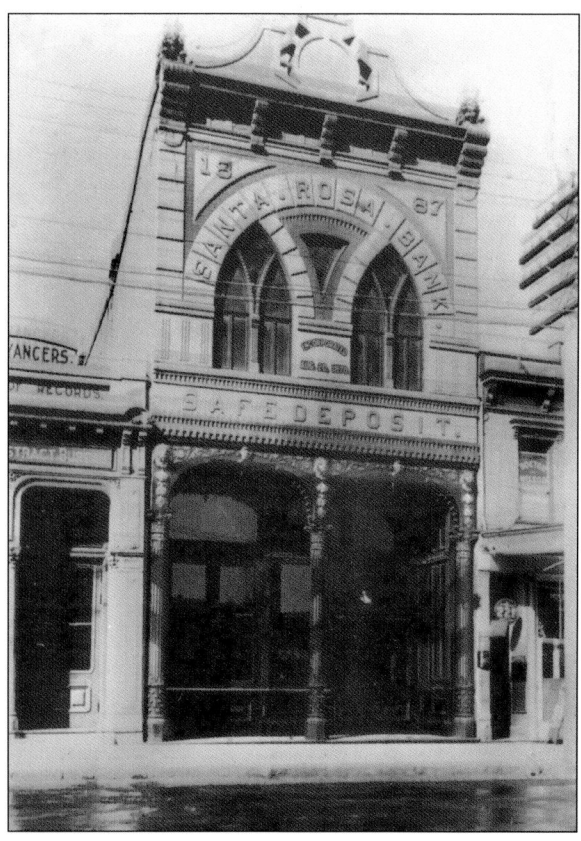

As the largest town in the valley, Santa Rosa became its banking center, with Santa Rosa Bank (left), organized by E.T. Farmer in 1870, Santa Rosa Savings Bank, established in 1873 by Ted Hahman and A.P. Overton, and the Exchange Bank, founded by Manville "Matt" Doyle and his son Frank in 1890. Frank Doyle, more than any other local banker, saved cash-starved farmers from bankruptcy during the Depression, and left many other legacies to Santa Rosans. He purchased the beautiful acreage at the confluence of Spring and Matanzas Creeks to create Doyle Park, named not for him but for his son Frank Jr., who died at age 13. When Doyle himself died in 1948 at age 85, he left his controlling interest in Exchange Bank to endow an ongoing scholarship fund for Santa Rosa Junior College students. To date over 55,000 students have received Doyle scholarships. (Courtesy of the Sonoma County Museum.)

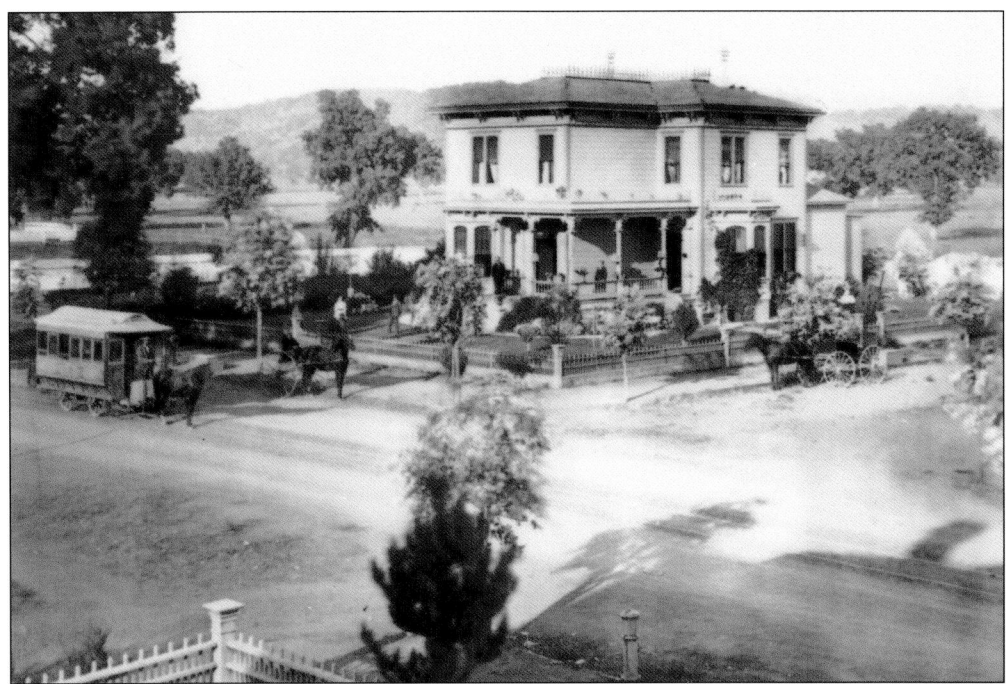
A streetcar of the City Railroad, pulled by a single horse, travels down McDonald Avenue. (J.H. Downing photo, courtesy of the Healdsburg Museum.)

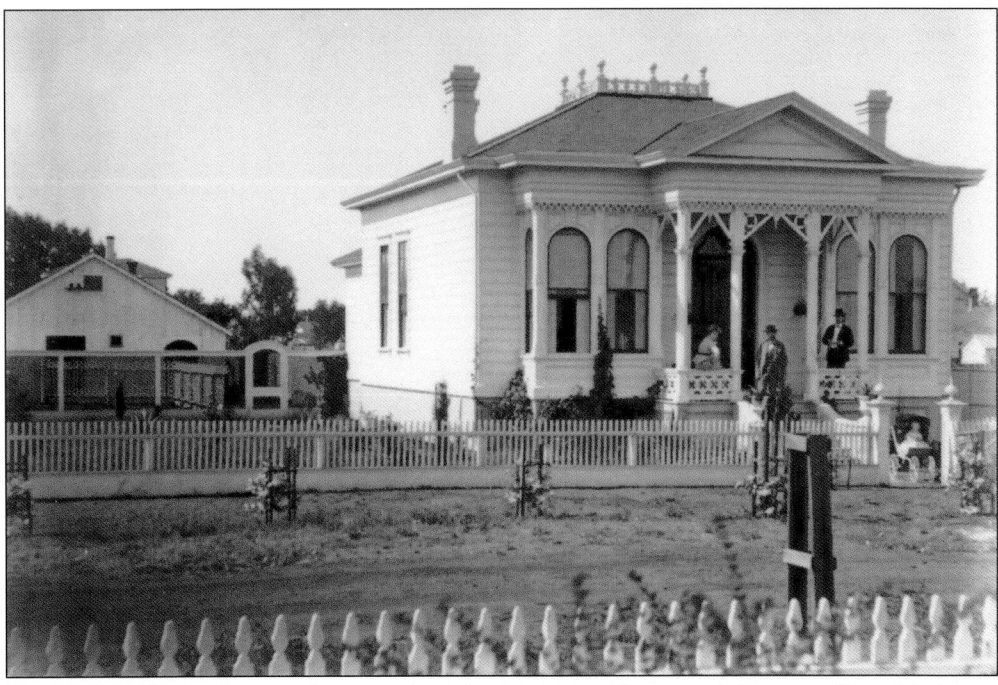
Even relatively modest-sized homes had fascinating architectural features, like this house belonging to the Frost family. (J.H. Downing photo, courtesy of the Healdsburg Museum.)

In the days when families typically had six or eight children, a family gathering could easily overwhelm a front porch. Here the Fulkersons gather for the 50th anniversary of Amanda (Cockrill) Fulkerson (second from left) and Stephen T. Fulkerson (third from right) on August 29, 1908. Their 7 children, 24 grandchildren, and 10 great-grandchildren helped celebrate at their home at 729 Santa Rosa Avenue. Young Amanda came to Santa Rosa by wagon in 1853 with the Cockrill-Hagens party that delivered a number of the valley's early settlers; Thomas arrived the following year. (Courtesy of the Sonoma County Museum.)

Santa Rosa girl Blanche Espey posed at age 16 in this ornate blouse, with a coiffure typical of the era, May 1903. (E.F. Briggs photo, courtesy of the Sonoma County Museum.)

Local Judge Emmett Seawell owned this corner house, shown here c. 1912 with two girls on the front porch. (Courtesy of the Sonoma County Library.)

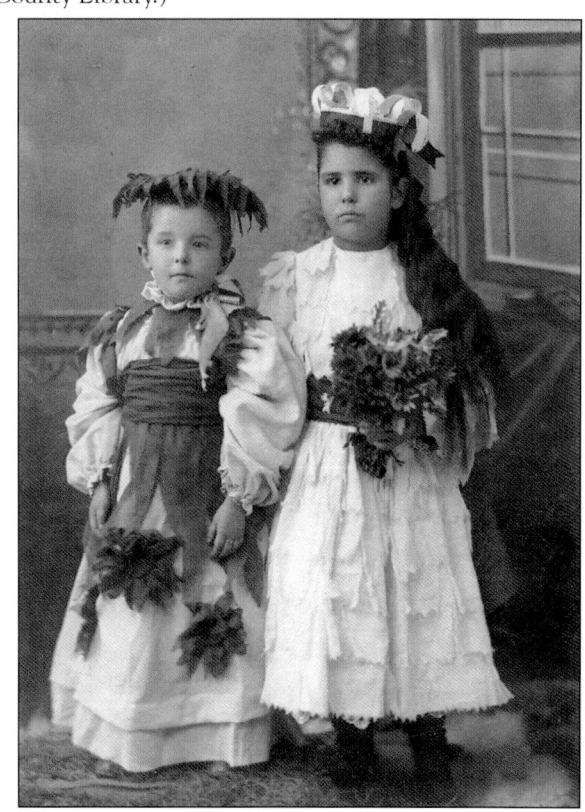

Margaret Belle Bower and her little brother Grover got all dressed up in white gowns and festive hats, perhaps for the Rose Parade, in the early 1900s. Margaret's grandfather, Moses Bower, founded the Bower Cigar Factory in Santa Rosa. (Minerva Salisbury Collection, courtesy of the Sonoma County Museum.)

Children clown for photographer Claude Sandborn, with two unidentified homes in the background. (Sandborn collection, courtesy of the Sonoma County Museum.)

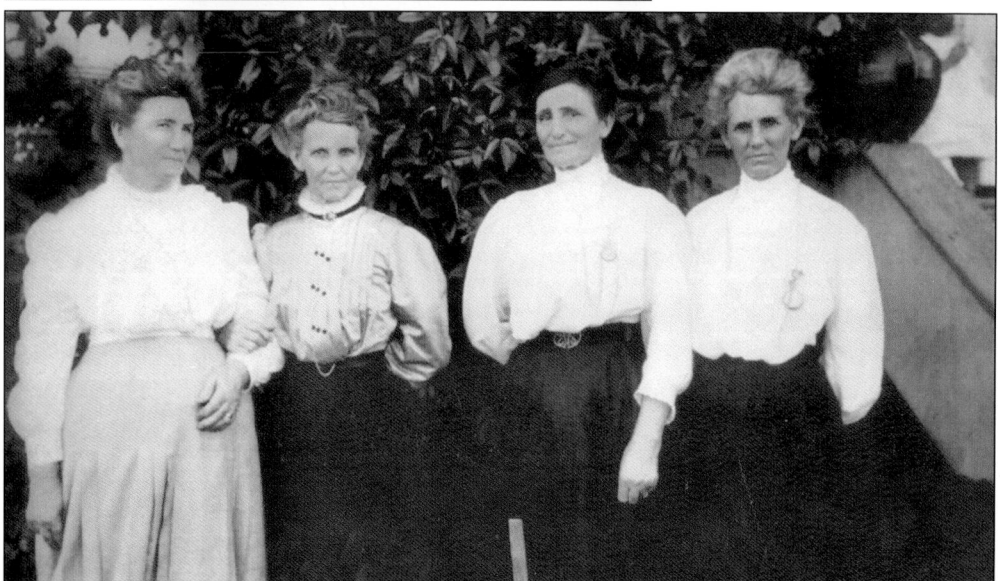

The women of the pioneer Cockrill family, who came by wagon train to Sonoma County in 1853, were among the movers and shakers of late 19th century Santa Rosa. From left to right are Amanda (Cockrill) Fulkerson, Mary Milvina (Cockrill) Foster, Elizabeth Milvina (Cockrill) McGuire, and Genette (Cockrill) Bardin, c. 1900. In the era before wristwatches, women, lacking pants pockets, pinned watches to their blouses. (Courtesy of the Sonoma County Museum.)

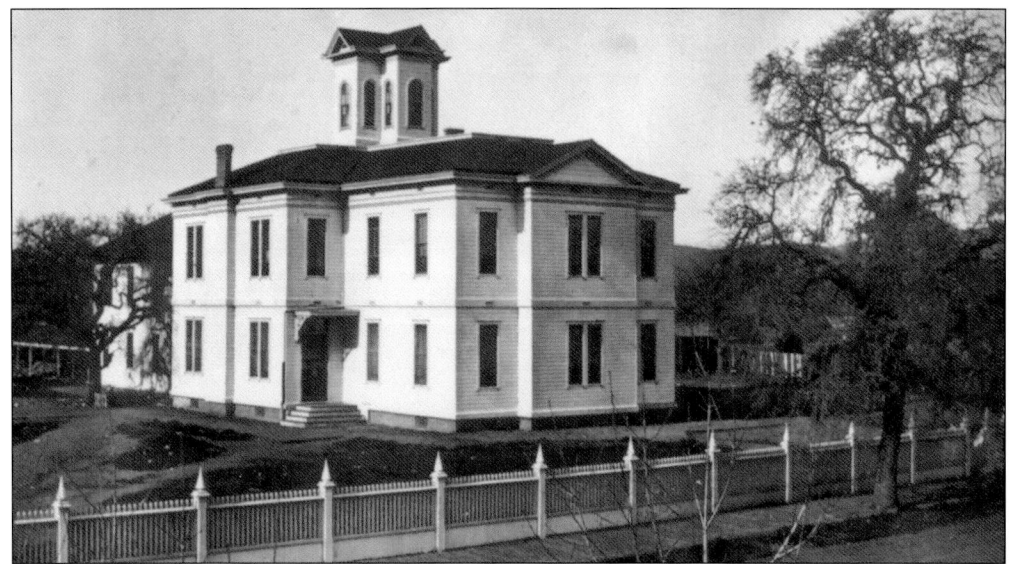

Santa Rosa High School began in 1878. Students met in the Fourth Street grammar school, above in 1880, designed by A.P. Petit, and constructed in 1874. The school board's commitment to higher education was a bit shaky. They discontinued the high school in 1880, then reinstated it in 1883. SRHS got its own building on Humboldt Street in 1895. A second grammar school opened in 1884 at Eighth and Davis Streets called West School, then Davis School, and finally Lincoln. It enjoyed a second career as the Lincoln Arts Center, with spaces for art workshops, community organizations, and a small press. In the 1980s it also served as a venue for Santa Rosa Players and Actors Theatre. (Courtesy of the Sonoma County Museum.)

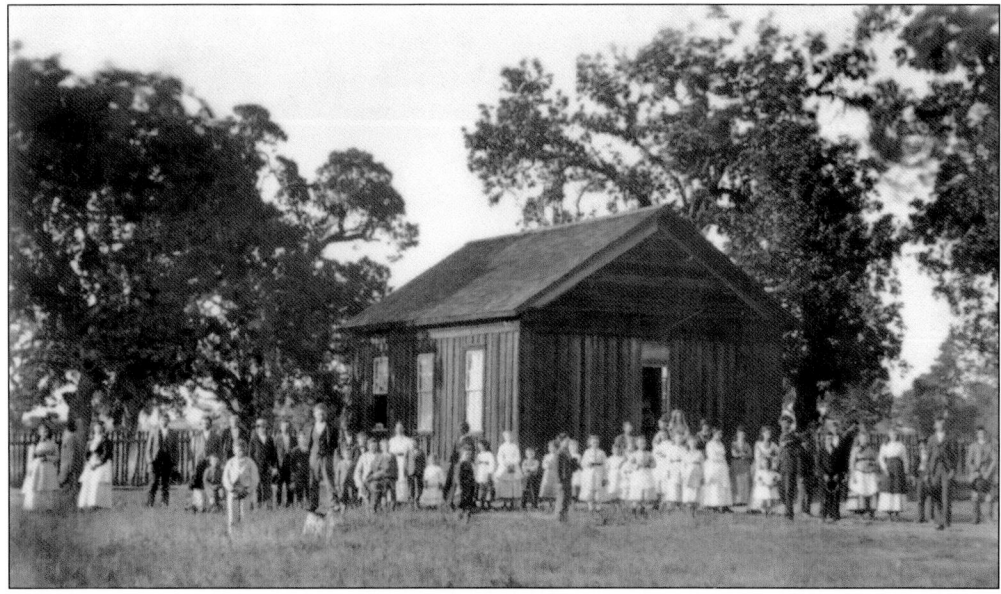

Kids outside town went to one-room schools like the Hall District School four miles west of Santa Rosa, not far from the Laguna de Santa Rosa. F.J. Tomlinson was the teacher. (J.H. Downing photo, courtesy of the Healdsburg Museum.)

Boys and girls dressed in their best and posed at the entrance of Luther Burbank School on Ellis Street, c. 1900. The building was damaged in the 1906 quake. (Courtesy of the Sonoma County Museum.)

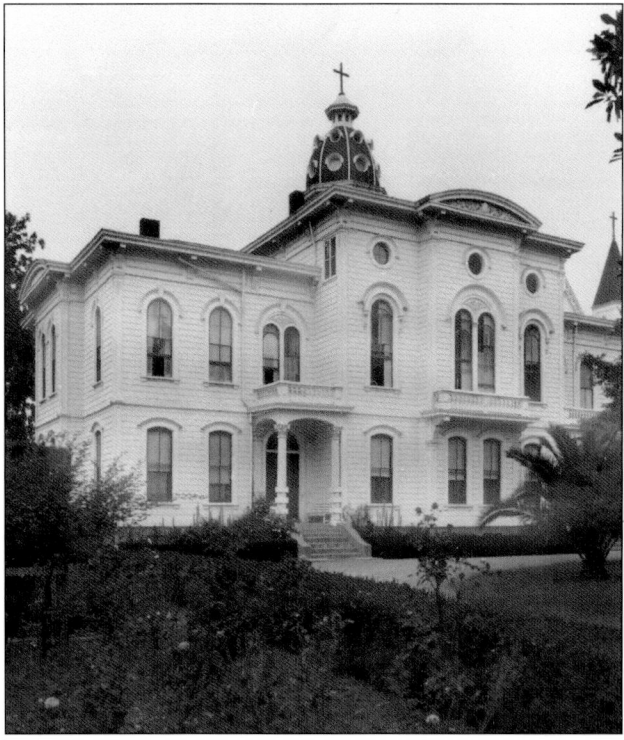

This Victorian Italianate building on B Street was the Christian College, built in 1872 by the Disciples of Christ. In 1880 the Sisters of St. Ursula reopened it as a school for girls. Ursuline Academy closed in 1936 due to competition from Santa Rosa Junior College, but it was the forerunner of today's Ursuline High School, north of town next to Cardinal Newman, a Catholic high school for boys. Santa Rosa was home to several colleges; Pacific Methodist College (for which College Avenue was named) moved here from Vacaville in 1871. In the 1870s, Miss Chase's Seminary for Girls was located on College Avenue near King Street. (Courtesy of the Sonoma County Library.)

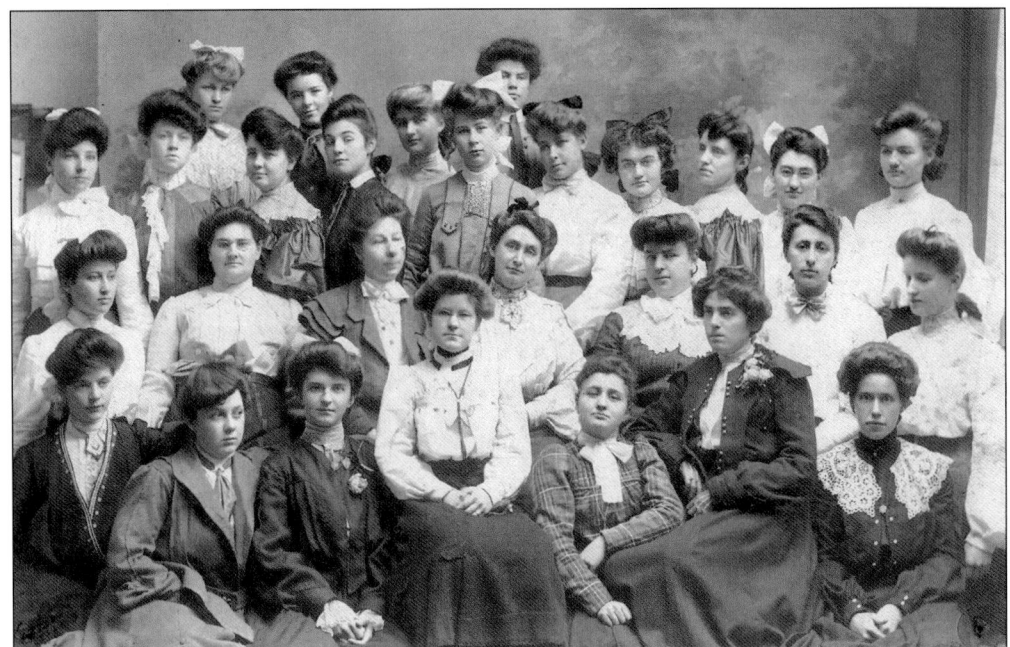
Promising young women of Santa Rosa, possibly from Mrs. Chase's Seminary, look at the camera with confidence in the 1890s. (Courtesy of the Sonoma County Museum.)

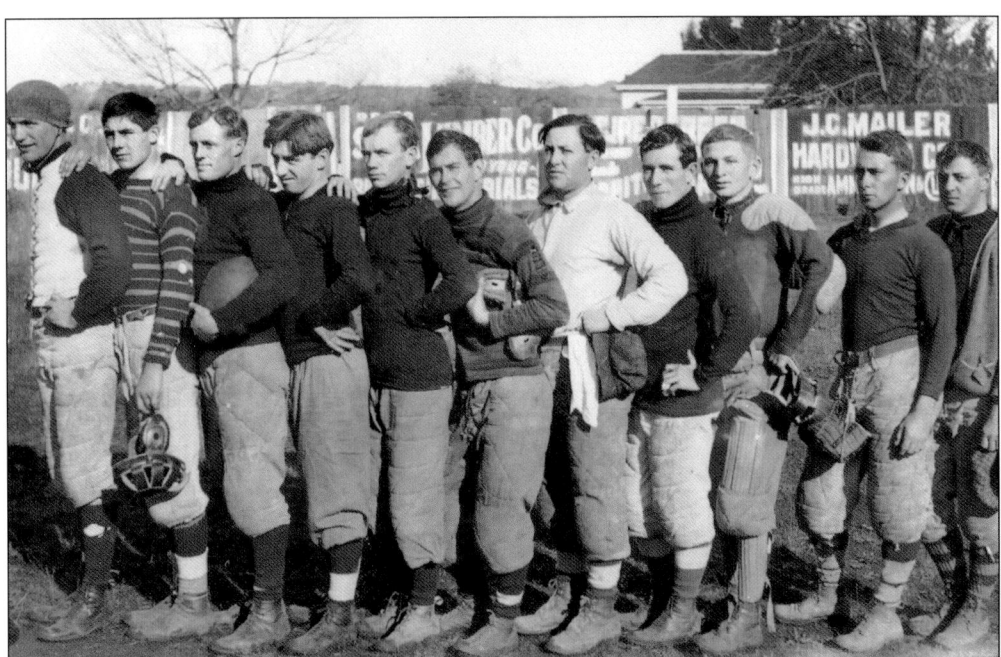
The Santa Rosa High School alumni football team poses, c. 1900. Padding was minimal, consisting of quilted pants and leather helmets like the one held by the player second from left. (Sandborn Collection, courtesy of the Sonoma County Museum.)

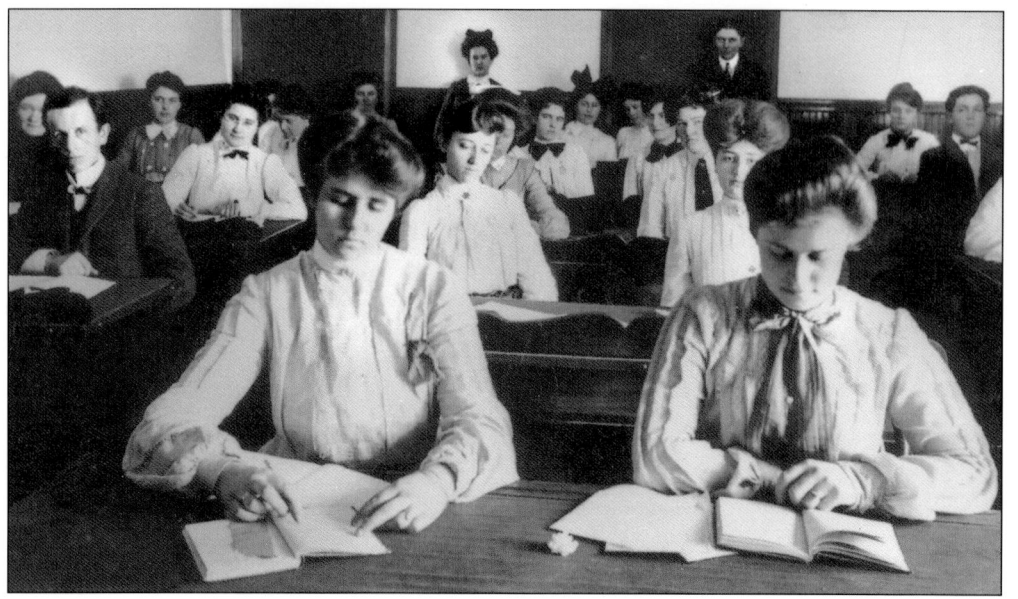

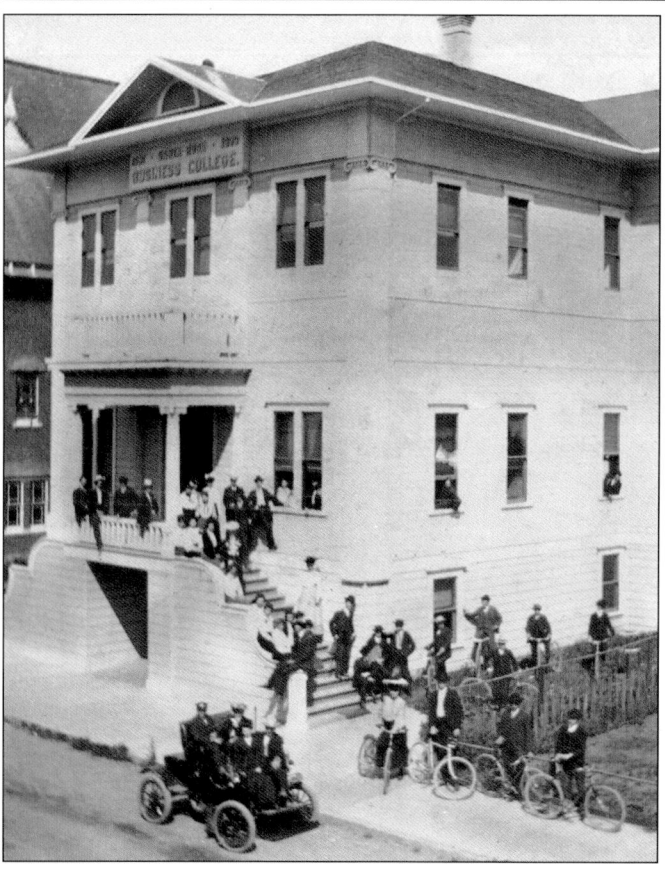

Both men and women (above) attended the popular Sweet's Business College, also called Santa Rosa Business College, founded in 1891. The college (left) attracted students from throughout the county. Students from western Sonoma County rode the electric railway to class. Founder James Sweet became Santa Rosa's mayor in 1898. Clyde Sweet, his nephew, later took charge of the college, which taught several generations of students, often the children of immigrants, the skills of the business world. (Courtesy of the Sonoma County Museum.)

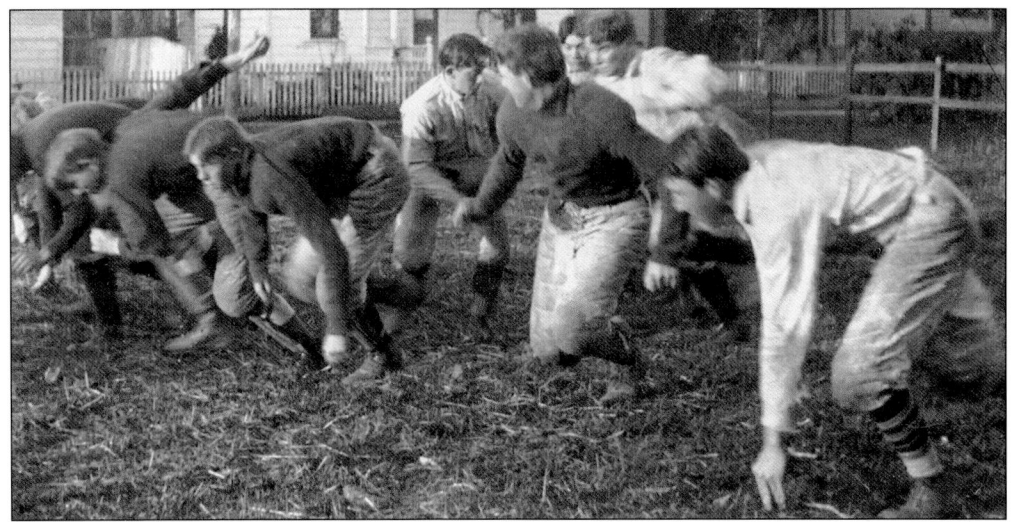
Besides teaching typing and other business skills, Sweet's fielded its own sports teams. Young men from Sweet's practice football out on the lawn. (Courtesy of the Sonoma County Museum.)

Santa Rosa High School had its own teams, which competed with Petaluma High School and other rivals. The batter is wearing an SRHS uniform, while the catcher's shirt has the Sweet's Business College Logo. (Courtesy of the Sonoma County Museum.)

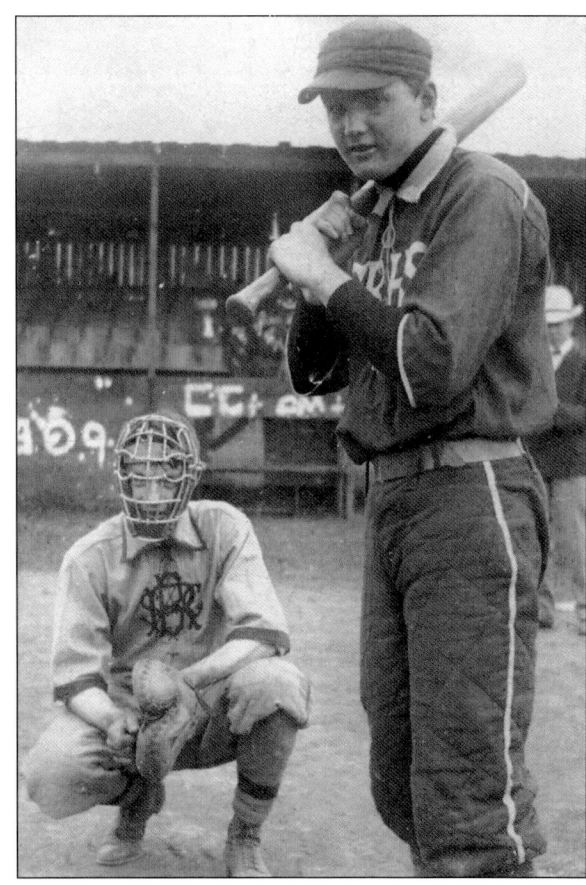

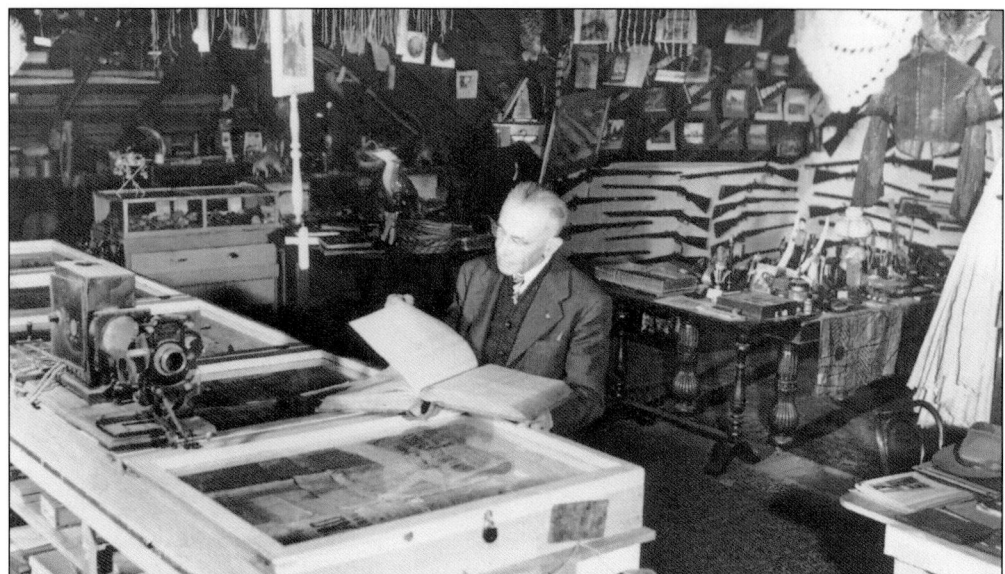

Sidney Kurlander (above) was born in 1879 above his family's Fourth Street cigar store and was an avid photographer and collector. After his death in 1958 his collection went to the local Scottish Rite Temple. When their B Street site was sold to Macy's, the Temple put the Kurlander collection up for auction. Fortunately Dayton Lummis, director of the newly created Sonoma County Museum, was on the spot with the high bid, saving most of Kurlander's photos and memorabilia for the public. (Courtesy of the Sonoma County Museum.)

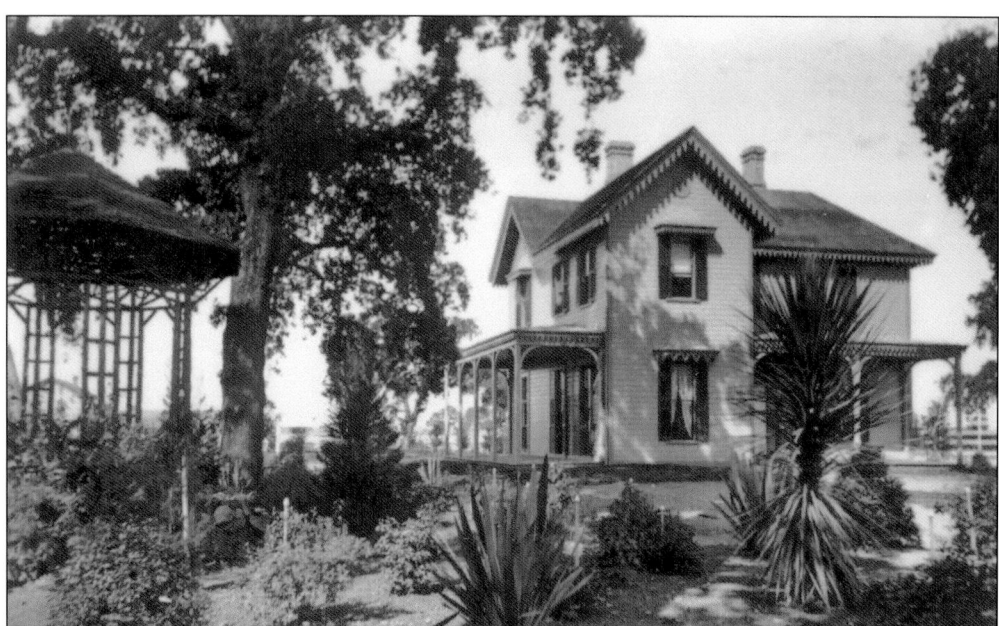

Starting in 1875, the firm of Downing, Rea, and Rauscher recorded an era of growth in Santa Rosa, taking photos of businesses and homes like the one above. In 1879 J.H. Downing became sole proprietor of their gallery on Third Street. His photos provide the most complete visual record of the town prior to the devastation of the 1906 earthquake. (J.H. Downing photo, courtesy of the Healdsburg Museum.)

Three
CATACLYSM AND REBIRTH

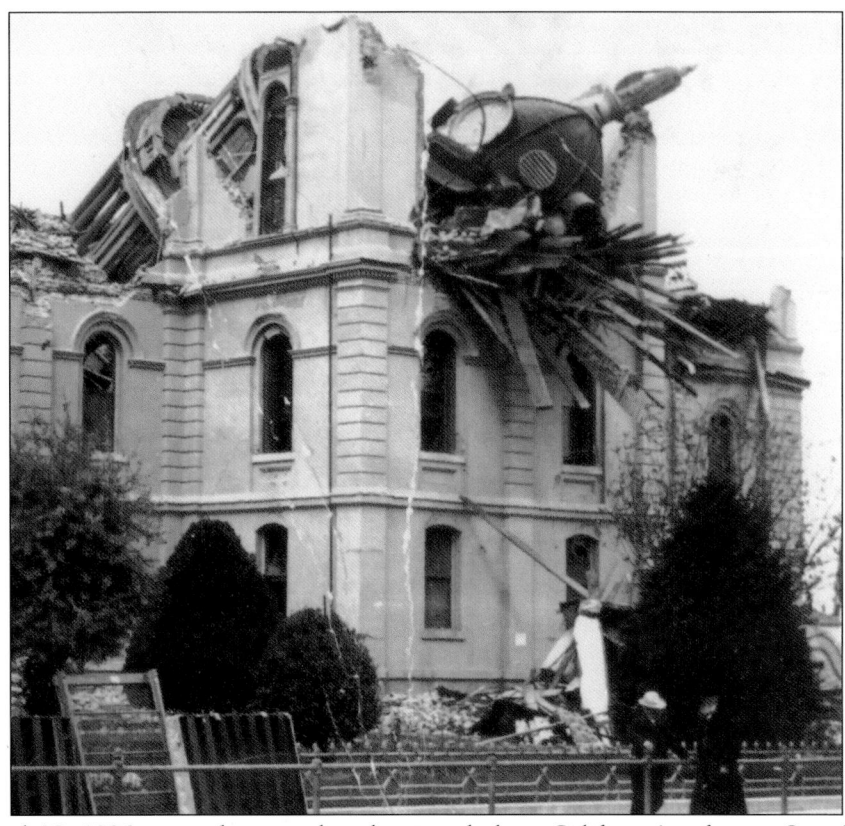

On April 18, 1906, a pre-dawn earthquake ripped along California's infamous San Andreas Fault. It was centered in Olema, near Point Reyes, and although the cataclysm is called the San Francisco Earthquake, the City of Santa Rosa, by then a thriving center with banks, mills, three railroads, and a population of 6,700, suffered far more damage proportionally. The dome of the Sonoma County Courthouse in the center of town (above) smashed into the stories beneath, and most of the downtown collapsed in a rubble of bricks and dust. Over 100 people were killed, many of them in the St. Rose, the Occidental, and other hotels. (Courtesy of the Sonoma County Museum.)

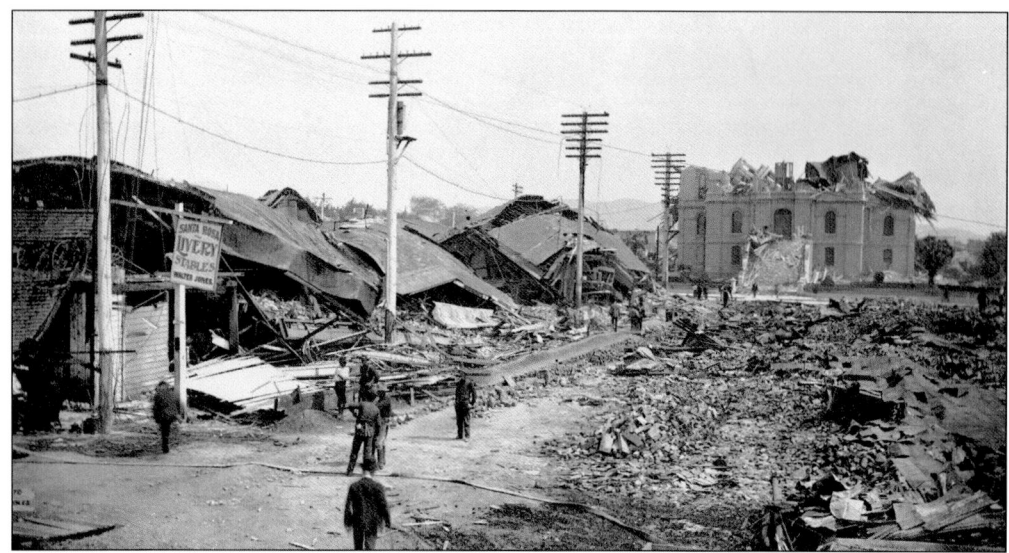

A fire started at Rochdale's Third and B Street store, sweeping through downtown and killing yet more people. Water mains broke, and the firehouse on Fifth Street collapsed, killing the fire horses. Firemen pulled their equipment by hand to the burning buildings and pumped water from nearby Santa Rosa Creek. In this view south along Mendocino Avenue, Walter Jones's ruined livery stable is on the left, with the courthouse in the distance. (LaCell and McClearie photo, courtesy of the Sonoma County Museum.)

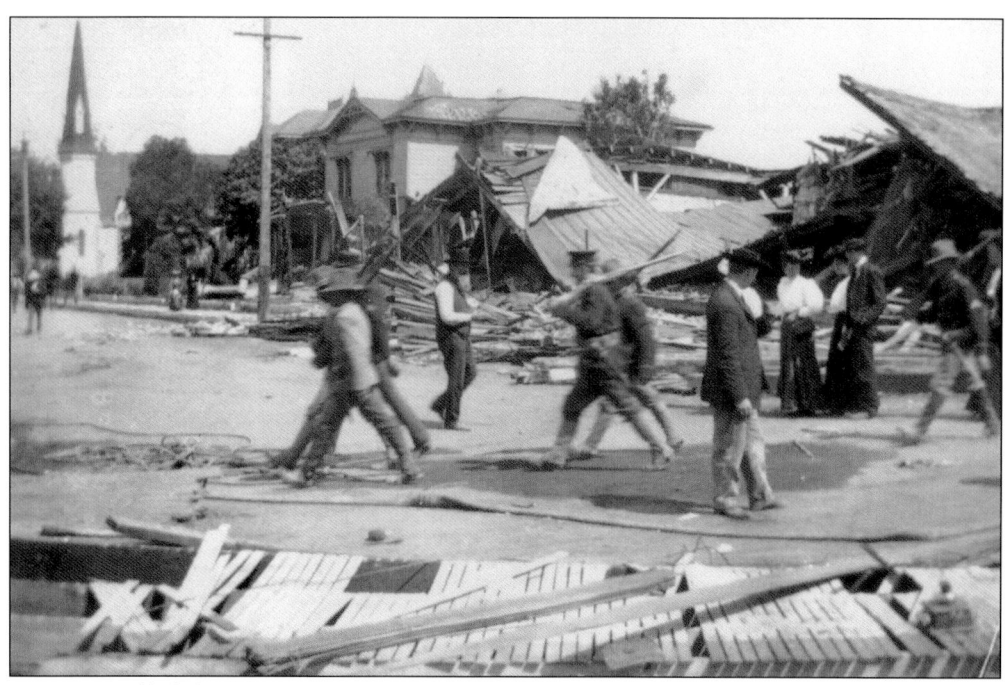

Troops patrolled the streets to keep order. (Courtesy of the Sonoma County Museum.)

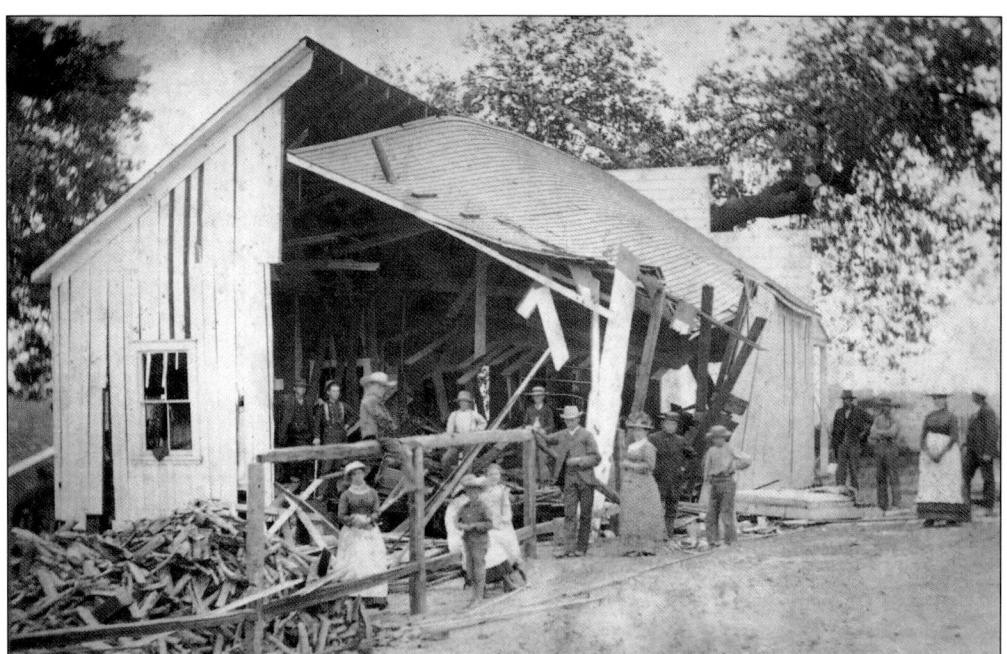

Even wooden structures collapsed, like the one shown above, trapping people in the wreckage. Within days the post office, banks, and the *Democrat* newspaper set up temporary quarters, so citizens could resume their lives until the town could be rebuilt. The county supervisors met on the lawn outside the ruins of the courthouse. (Courtesy of the Sonoma County Museum.)

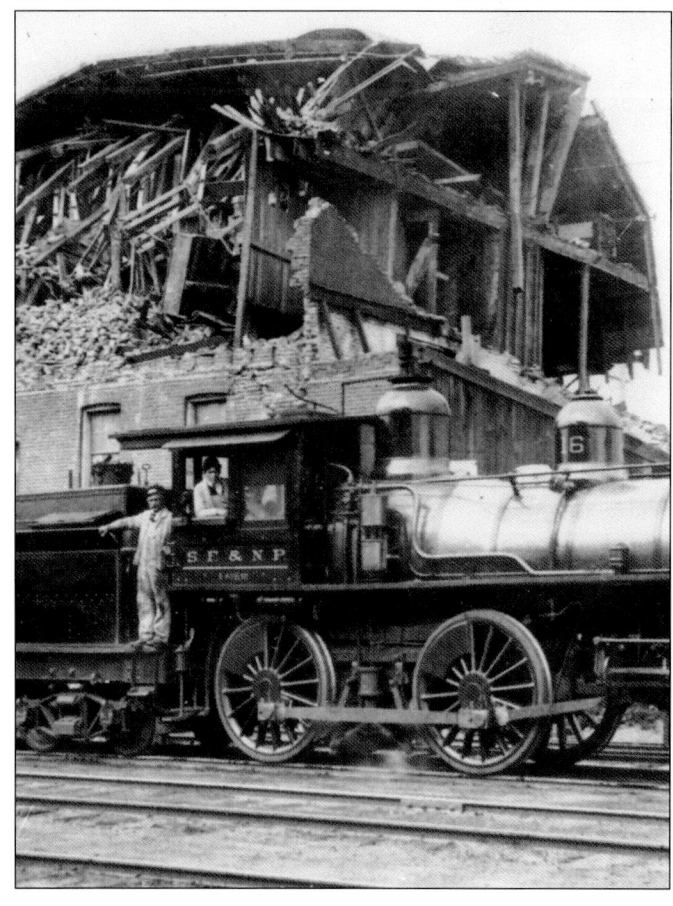

Petaluma and Sebastopol, relatively undamaged, sent food and medicine. Trains like this one by the ruined flour mill brought new material and hauled away rubble. (Courtesy of the Sonoma County Museum.)

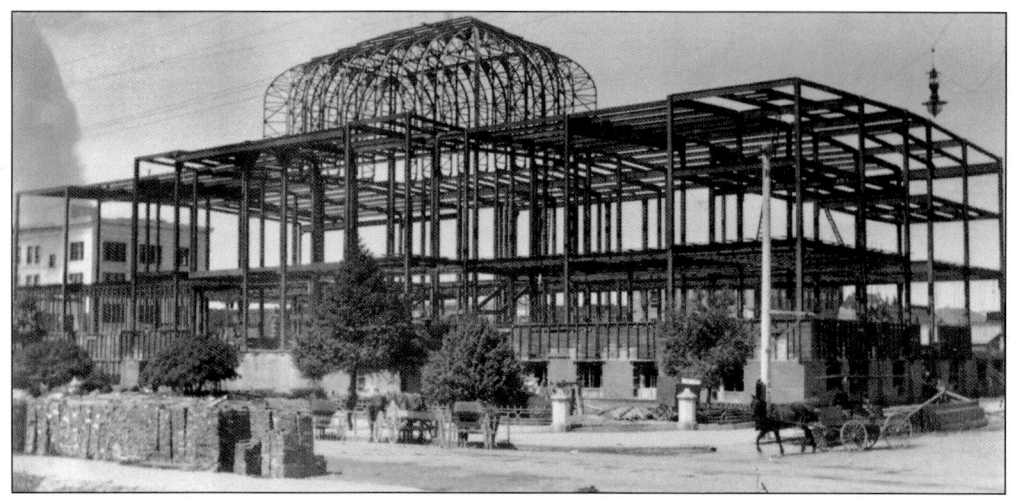

Santa Rosans met the challenge of rebuilding a 20th-century city on the dust of the old one. A prime order of business was drafting stringent building codes, calling for steel reinforcement. The new courthouse (above), designed by J.W. Dolliver, would become emblematic of the revived city. It was started in 1908 and dedicated in May 1910. Bricks and mortar were definitely out of favor with the Italian stonemasons who repaired the Western Hotel and built La Rose Hotel and the depot in Railroad Square with basalt blocks quarried near Annadel. (Courtesy of the Sonoma County Museum.)

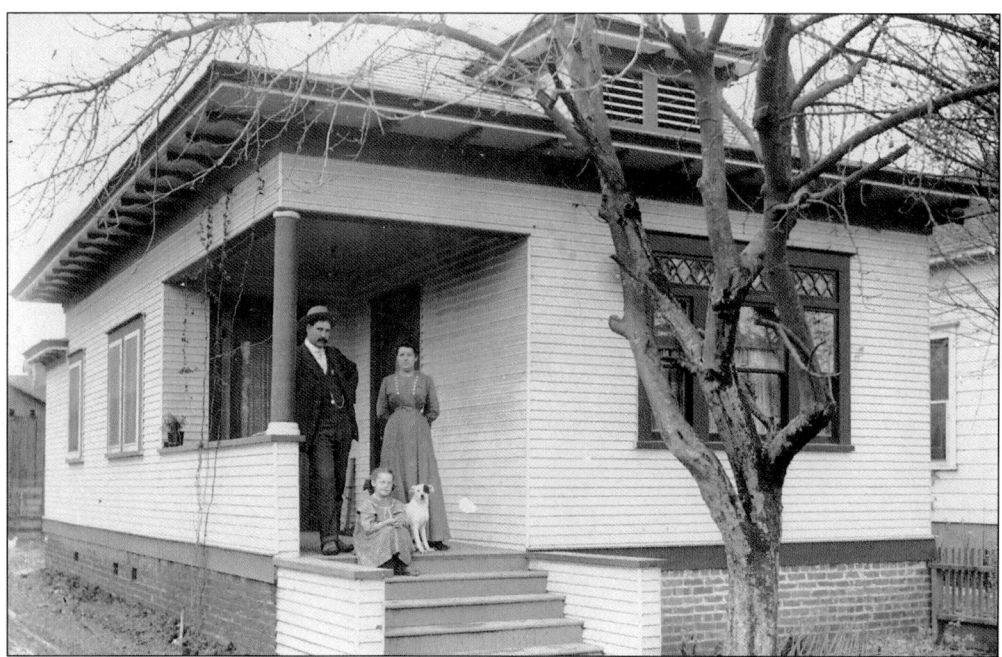

In the 1800s Santa Rosans, fearing fire, built downtown buildings of brick and mortar. When the earth shook, those buildings crumbled. Many wooden homes, although damaged, could be repaired, and new homes also went up to house those who remained in Santa Rosa to weather the long process of reconstruction. Above are Mr. and Mrs. Alpine and their daughter Helen at their home at 13 Davis Street in 1907. (Courtesy of the Sonoma County Museum.)

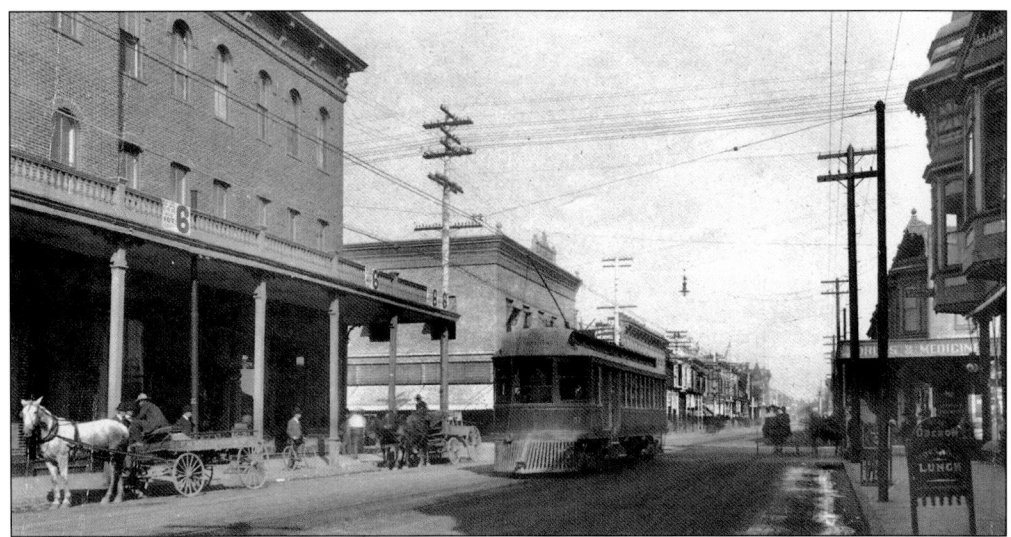

Streetcars glided down the avenues of the new Santa Rosa. The Petaluma and Santa Rosa Electric Railway provided a direct link to Sebastopol, with 20 cars arriving daily with produce and students headed for Sweet's Business College and other schools. In 1927 the P&SR built a new stucco station (now occupied by Chevy's Restaurant) at Fourth and Wilson Streets. (Courtesy of the Sonoma County Museum.)

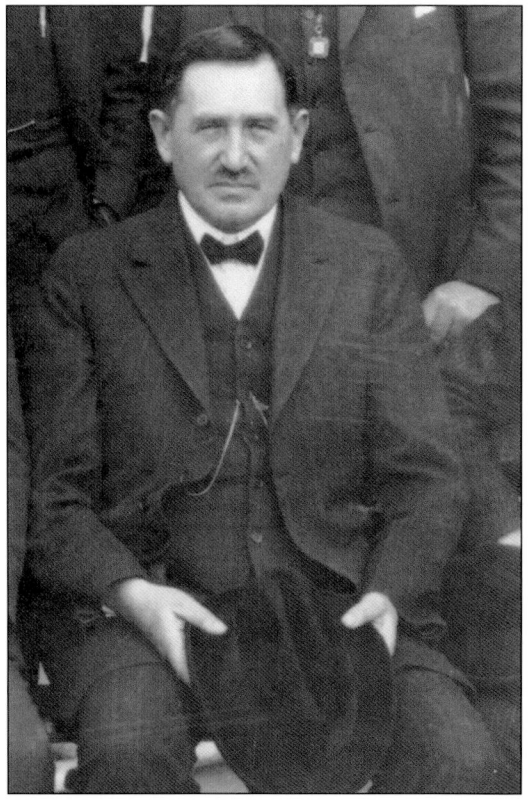

Max Rosenberg, shown here in 1925, was one of early Santa Rosa's great entrepreneurs. After emigrating from Poland, he went into business with his uncle, Wolf Rosenberg, in Healdsburg in 1880. In 1896 he branched out on his own in Santa Rosa, starting the Red Front Store, later known as Rosenberg's. The store was hard hit by the 1906 quake, but Max bought several trucks full of goods, salvaged from the wreck of the downtown hotels, and soon reopened for business. Rosenberg was also a mainstay of the local Jewish community, serving variously as cantor and acting rabbi of the congregation that met at Germania Hall in the early 1900s. (Courtesy of the Sonoma County Museum.)

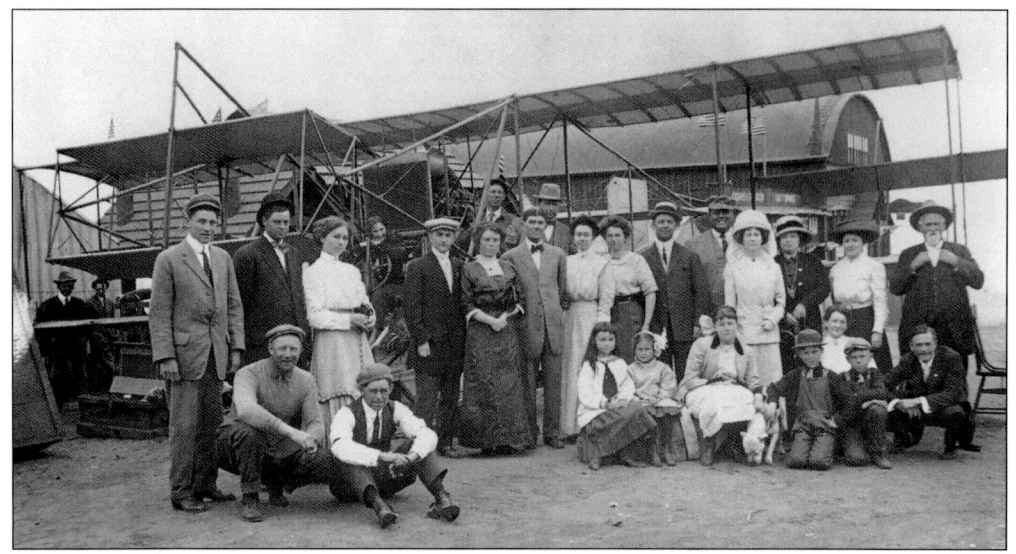

Petaluman Fred Wiseman (in front with white sleeves) flew into history on February 17, 1911, carrying 3 letters and 50 copies of the *Press Democrat*, which he dropped on subscribers along the way. The Smithsonian confirmed his 14-mile jaunt from Petaluma to Santa Rosa as the world's first official airmail flight. Wiseman later gave up flying for his first love, car racing. "I wonder how most of us were crazy enough to go up in the air in those kites we used to fly." Wiseman said later in life. "I must have been nuts." He died in 1961, aged 85. His plane is in the Smithsonian. (Courtesy of the Sonoma County Museum.)

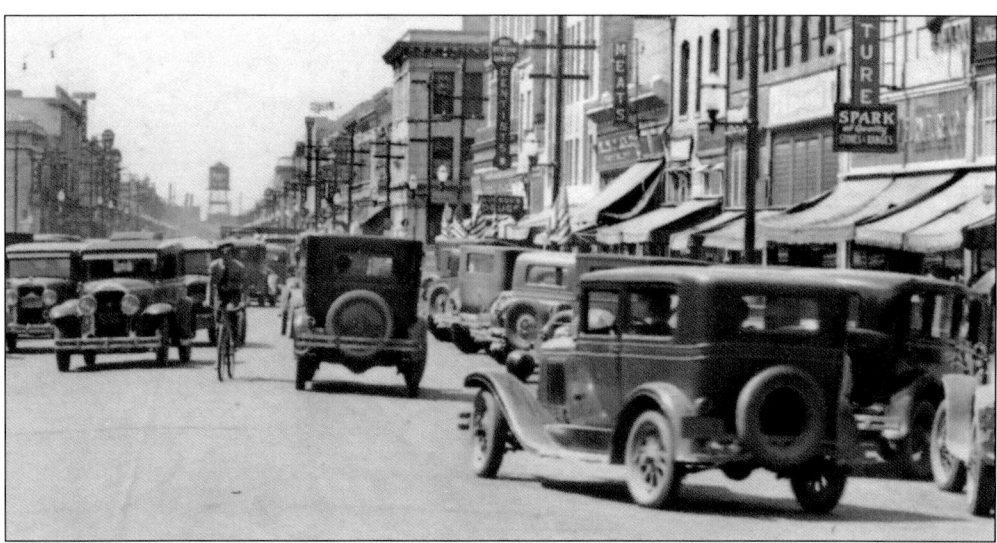

Santa Rosa enjoyed vigorous growth in the 1920s; Fourth Street (seen here looking west) was crowded with cars, bicycles, and signs for offices, butcher shops, and furniture stores. (Courtesy of the Sonoma County Museum.)

Exchange Bank, on the northwest corner of Fourth Street and Mendocino Avenue, was founded by the Doyle family. On the second floor were the offices of Dr. Herrick and Dr. Hewitt, a dentist. Attorneys who practiced across the street at the courthouse occupied the third floor. A new Exchange Bank building occupies the same corner today. (Courtesy of the Sonoma County Museum.)

Old Redwood Highway went north along Santa Rosa Avenue, skirted Courthouse Square, then continued up Mendocino Avenue In this 1935 view of Mendocino Avenue from the corner of Fifth Street, the Rosenberg Building, built in 1921, is on the left; Exchange Bank is on the right. The Redwood Highway sign arches over Mendocino Avenue in the center, in front of the courthouse. On the right is the Bee Hive Restaurant and beyond it are a cigar store and Jerry's Restaurant. (Courtesy of the Sonoma County Museum.)

The Redwood Highway opened in 1924. On August 27, 1926, Vera Churchill (Miss Healdsburg), Bertha Knudsen (Miss Redwood Highway), and Wilma Steiner (Miss Santa Rosa) celebrate the opening of the Redwood Highway segment between Santa Rosa and Healdsburg. (Courtesy of the Sonoma County Museum.)

Dry Creek Pomo Manuel Cordova joined about a dozen other Native American runners for the "Indian Marathons" of 1927 and 1928. Cordova is seen here in a later photo wearing Pomo dance regalia, a flicker feather headband. The Redwood Highway Association, based in San Francisco, created the race as a publicity stunt to promote the new road. Northern California Indians, including Pomo and Karuks, competed along with Zunis from Arizona and even an entry from Canada for a $5,000 prize, running a course from San Francisco to Grant's Pass, Oregon. The rules were simple: "Finish in 15 days, don't accept lifts, and don't get off the Redwood Highway." The check-in point in downtown Santa Rosa was the Occidental Hotel. (Courtesy of the Healdsburg Museum.)

Frank Doyle (center, in dark suit) cuts a chain with a blowtorch to open the Golden Gate Bridge on May 28, 1937. Doyle, a founder of Exchange Bank, and other county entrepreneurs were among the chief organizers of the project, which opened the county to auto tourism and increased commerce with San Francisco. (Courtesy of Exchange Bank.)

No event brought more business to Sonoma County than the opening of the bridge, and no one worked harder to see it built than Frank Doyle (on the left), seen here with famed horticulturist Luther Burbank. Doyle assumed presidency of the Exchange Bank when his father, Manville Doyle, died in 1916. In 1923, as president of the Santa Rosa Chamber of Commerce, he invited 100 North Bay businessmen to Santa Rosa City Hall to form the Bridging the Golden Gate Association. The association convinced local counties to raise $35 million in bond money to construct the span. (Courtesy of the Sonoma County Museum.)

The Santa Rosa High School football team of 1927 poses on the bleachers with the school in the distance. The 1895 high school on Humboldt Street burned down in 1921. The current high school on Mendocino Avenue, designed by W.H. Weeks of San Francisco and his colleague William Herbert of Santa Rosa, opened in 1925. As Santa Rosa expanded in all directions, it added high schools: Montgomery High in Bennett Valley, Piner High at the north end of town, and in the southwest area, Elsie Allen High in 1994, named for one of the finest Pomo basket makers. Most recently María Carrillo High, which opened in 1996 in Rincon Valley, was named for the woman who in 1837 built the first European home in the Santa Rosa Valley. (Courtesy of the Sonoma County Library.)

Students from Santa Rosa High School's Class of 1925 gather on the steps of their new school. (Courtesy of the Sonoma County Library.)

Students parade down Fourth Street to urge citizens to vote for school bonds in the October 10, 1939 election. Signs read, "We want a new Jr. High" and "Santa Rosa High—Take us out of the basement." At left is Exchange Bank at the corner of Mendocino Avenue; on the right is the Rosenberg Building, with Karl's Shoes on the corner. (Courtesy of the Sonoma County Library.)

Students who passed through this arch, shown in 1941, received some of the best education in the state. Santa Rosa Junior College, California's tenth junior college, was founded in 1918 as a local campus offering the first two years of a four-year education at UC Berkeley. Vocational training was a later addition. The nursing school, founded in 1943, was prompted by World War II. The arch, which is known as Legion Gate, was constructed in 1935 with funds from the American Legion. (Courtesy of the Sonoma County Library.)

SRJC shared the Santa Rosa High campus until 1931, when it acquired the site on Mendocino Avenue and the student body of more than 300 moved into the new Pioneer Hall. Geary Hall and Tauzer Gym, named for Clarence "Red" Tauzer, were added in 1932 and 1935. Physics instructor Floyd Bailey ran the college from 1921 to 1957 and presided over the college's golden age of building. In the late 1930s the Public Works Administration, a New Deal agency, funded construction of Analy Hall (left, 1941), Bussman Hall, and Burbank Auditorium, filling out the core campus. SRJC began with eight instructors and 19 students; in the 1990s enrollment topped 37,000 and SRJC added a Petaluma campus. (Courtesy of the Sonoma County Library.)

Along with its school teams Santa Rosa also fielded its own semi-pro football team, the Bonecrushers, in the late 1940s. Largely comprised of former Santa Rosa High School and Santa Rosa Junior College players, the Bonecrushers were generally "trounced" by their main rivals, the Petaluma Leghorns, led by former SRJC star Gene Benedetti. (Courtesy of the Sonoma County Library.)

Ernie Nevers, a kid from Rincon Valley, played on SRJC's first football team. After coaching the SRJC team for a year, he went on to fame as an All-American at Stanford. Despite Stanford's loss to Notre Dame in the 1925 Rose Bowl, Nevers's performance was notable, and eventually he was picked up by the St. Louis Cardinals. In one memorable game he led St. Louis to a 40-6 rout of the Chicago Bulls, scoring all 40 points himself in a record-breaking performance. The U.S. Postal Service included him in its 2003 series of early football heroes. (Courtesy of the United States Postal Service.)

Santa Rosa's First Baptist Church was actually organized in the town of Franklin in 1852. When nearby Santa Rosa became the county seat, churchgoers hitched up six oxen and hauled their house of worship to the new town. Made from a single 275-foot redwood tree, the church was built in 1873 at Fifth and Ross. At left are a few members of the congregation in 1923. Cartoonist Robert Ripley, whose mother attended the church, featured it in his "Believe It Or Not" newspaper column. The City of Santa Rosa bought the church in 1957 and later moved it to Juilliard Park, where it became the Ripley Museum in 1970. (Courtesy of the Sonoma County Library.)

Church architecture varied considerably. Santa Rosa's Methodist Episcopal Church on Third Street (above left) has echoes of simple New England styles. The Presbyterian Church on Johnson Street, shown above right in the 1940s, is more ornate. (Left: T.L. Rea photo, courtesy of the Healdsburg Museum. Right: Courtesy of the Sonoma County Museum.)

St. Rose Catholic Church, an example of the Gothic Revival style, was built in 1900 by Peter Maroni and other stone masons from northern Italy, who used basalt cut at the quarry owned by James and Mark McDonald. When St. Rose Parish was originally founded in 1877 it encompassed most of Sonoma County. A separate parish was established in Healdsburg in 1884, leaving Santa Rosa Catholics on their own. The church, at 549 B Street, no longer has its delicate spire but is otherwise intact. It is included in the St. Rose Walking Tour brochure published by the City of Santa Rosa's Cultural Heritage Board. (Courtesy of the Sonoma County Museum.)

The Chinese sign on Mike Cohen's plumbing store, located on Santa Rosa Avenue between Sonoma Avenue and First Street, reflects its location in Santa Rosa's Chinatown. A district of about 200 residents, Chinatown was wedged between D Street and Santa Rosa Avenue, near today's City Hall. (Song Wong Bourbeau Collection, courtesy of the Sonoma County Museum.)

Song Wong Bourbeau (1909–1996) was the daughter of Tom Wing Wong, Chinatown's unofficial mayor. Wing died in 1918, one of many victims of the flu pandemic. Bourbeau, who suffered as the only Chinese student at Fremont Grammar School, went on to study at Santa Rosa Junior College and Stanford. She married Charles Bourbeau and inherited the Jam Kee Restaurant. As a tireless volunteer for local service clubs and a charter member of the local Soroptimist Club, she was the first Santa Rosan picked by the American Legion Auxiliary as its Woman of the Year in 1985. She left numerous artifacts from Santa Rosa's vanished Chinatown to the Sonoma County Museum, which named its meeting room in her honor. (Song Wong Bourbeau Collection, courtesy of the Sonoma County Museum.)

David Loong (above) stands in front of the Jam Kee Restaurant, founded by Jam Kee Poi, Song Wong Bourbeau's grandfather. Poy Jam (right) was the chef there for many years. Because of discrimination and the prohibition against Chinese naturalization in the late 18th and early 19th centuries, Chinese men generally left their wives and children in China. Song Wong and her mother, Lun Wing, were among the few women in Santa Rosa's Chinatown. The restaurant first opened its doors on Second Street. In 1920 it moved to Third Street, where it thrived on lunchtime business from courthouse employees, and finally relocated to Fifth Street (Song Wong Bourbeau Collection, courtesy of the Sonoma County Museum.)

Work on Highway 101 was going full speed ahead in 1948, when these photos were taken. Construction of a major state highway right through the center of town caused a monumental change in the dynamics of Santa Rosa. East-west streets were broken by the highway, and Railroad Square was cut off from the rest of downtown. As a result businesses around the tracks suffered. In the 1970s, local entrepreneurs revived the district, drawing upscale shops and cafes. The Railroad Square Historic District eventually achieved a distinct identity, but foot traffic between it and the remainder of downtown has never really revived. (Courtesy of the Sonoma County Library.)

Four

HARVEST OF GREEN, HARVEST OF STONE

Santa Rosa, surrounded by land rich in resources, received constant supplies from beyond its boundaries. Wineries like the one at Fountaingrove (above) thrived on the edge of the town. Here Japanese workers guide a wagon laden with grapes up to a platform. From there the harvested grapes will be unloaded, processed, and made into wine with the Fountaingrove label. Crops like prunes, apples, hops, and grapes arrived from the West County and from Los Guilicos Valley. The goods were not only consumed by Santa Rosans themselves but were also sent on their way by rail to wider markets. Cut stone also came by rail from Los Guilicos Valley and was used to rebuild Santa Rosa after the 1906 quake. (Courtesy of the Sonoma County Museum.)

Thomas Lake Harris, a late 19th-century guru, established the Fountaingrove Ranch in 1875 on land north of Santa Rosa (but today within the city limits). His utopian commune attracted wealthy followers, and the commune prospered, adding a winery and small book press. Commune member Kanaye Nagasawa built the Round Barn in 1899. Now surrounded by new development, the barn remains one of Santa Rosa's most recognizable structures. (Don Meacham photo, courtesy of the Sonoma County Library.)

The Fountaingrove winery was a great success, producing 200,000 gallons a year by 1890. However, Harris himself (at right) left his West Coast paradise under a cloud when would-be devotees claimed he made sexual advances. Kanaye Nagasawa, as the last surviving member of the commune, inherited the estate and continued to improve the winery operation. (Courtesy of the Sonoma County Museum.)

Nagasawa, shown here with young relatives, became known as the "Baron of Fountaingrove" and often entertained visiting dignitaries as well as fellow Santa Rosans. Nagasawa died in 1934, but the Santa Rosa group Friends of Kagoshima maintains a student exchange with Nagasawa's home region in Japan. (Courtesy of Kosuke Ijichi.)

Pioneer John Shackleford Taylor came west in 1850, and in 1853 settled a 1,500-acre ranch southeast of Santa Rosa. He gave his name to 1,400-foot Taylor Mountain. He also operated White Sulphur Springs Resort (later Kawana Springs), which was popular with San Franciscans who arrived by train. Taylor also planted crops and mined coal to sell in town. The mineral springs fell dormant when rocks shifted during the 1906 quake, but nature eventually corrected her mistake: after the October 1969 trembler, Kawana Creek flowed once again. Taylor died in 1927 at the age of 99. (Courtesy of the Sonoma County Museum.)

A wagon brings bales of hops into town in 1890. The sign on the wagon reads "Lee Bros & Co., Truckmen." Businesses in the background include a dentist's office and J.F. Sawyer, watchmaker and jewelers. (Courtesy of the Sonoma County Library.)

The soil along the Russian River and the Laguna de Santa Rosa was perfect for cultivating hops, an essential ingredient of beer. Families would sleep out in the fields during the hop harvest, then bring the sacks in to be weighed, a process shown in this 1926 scene. Sonoma County was a major hop producing region until the 1950s. (Courtesy of the Sonoma County Library.)

Plant wizard Luther Burbank came to Santa Rosa in 1876 and spent a half century here creating over 800 hybrid species in the garden adjoining his home on Santa Rosa Avenue. In his day he was as famous as Ford or Edison, and he helped place Sonoma County on the map as an agricultural eden. Distinguished visitors like Nobumi Hasegawa, shown here in 1925, and Jack London came to Santa Rosa to tour his greenhouse, which survived the 1906 earthquake and still stands next to the Burbank house. (Courtesy of the Sonoma County Museum.)

When German immigrant Joe Imwalle started Imwalle Gardens in 1886, his Third Street property was surrounded by fields and orchards. He raised corn, beans, and tomatoes and sold them from his wagon. His sons Joe Jr. and Henry bought surrounding hop fields and prune orchards, increasing the family holdings to about 60 acres. Today the Imwalles do not need to bring their produce into Santa Rosa, because Santa Rosa has expanded out to surround them, leaving Imwalle Gardens an island of green in suburbia. Their store, run by Joe's grandson Joe III (right) is at 685 West Third near Dutton Avenue and is a popular stop on the county's Farm Trails map. (Photo by Simone Wilson.)

Italian immigrants to the Santa Rosa area came from Tuscany and worked the quarries in the area that is now Annadel Park. Rincon Hotel, also called the Stone House, was built shortly after the 1906 quake and run by Massimo Galeazzi as a rooming house for quarry workers. Stone for the first floor was quarried behind the house. When the wooden second story (shown here) burned in 1911, Massimo rebuilt that in stone as well. The Galeazzis, who originally lived upstairs, moved out in 1926, but continued to keep the Stone House open for boarders. It still stands on the north side of Highway 12. (Courtesy of the Sonoma County Museum.)

The Melitta Band, comprised of workers from Melitta area quarries, posed outside one of their favorite hang-outs. Thomas Gemetti, who emigrated from the Italian-speaking region of Switzerland, started the Enterprise Liquor Store, later called Northwest Liquors and finally just Gemetti's. His son Fred's head is just visible in the open doorway in this December 26, 1908 photo of the store, rebuilt after the quake. During Prohibition Mrs. Gemetti cooked food for the restaurant out front, while liquor flowed in the back room. The family operated the store until 1954, when they sold the property to the phone company. (Courtesy of the Sonoma County Museum.)

Pictured, from left to right, are Guisto Galeazzi, Gus Lotso, and Massimo Galeazzi, cutting stone, c. 1920. Fisher and Kinslow already ran Santa Rosa Marble Works at Fourth and Davis when Galeazzi arrived from Italy's Carrara region in 1901. He founded Santa Rosa Monument on Fifth Street, but in 1933 the companies merged to become North Bay Monument. Later the Galeazzis became sole owners. In the 1990s Massimo's grandson Gary Galeazzi moved the family business to Rohnert Park. (Courtesy of the Sonoma County Museum.)

The Wymore Quarry and others like it produced basalt blocks for building and paving. Much of the material was loaded at the Annadel and Melitta Stations and went south on the Southern Pacific Line. It ended up in San Francisco, where it was used for buildings and cobbled streets. Other trains went to Santa Rosa, where masons used the stone to rebuild Santa Rosa after the 1906 quake. Note the rails in the foreground, which carried stone downhill to the railway stations. (Courtesy of the Sonoma County Museum.)

Both before and after the quake, four expert stone masons—Peter Maroni, Massimo Galeazzi, Natale Forni, and Peter Deghi—used stone blocks cut at Annadel to build landmarks that still stand in Santa Rosa, including the St. Rose Church (above) and four stone edifices in Railroad Square: the depot (now the Visitors Center), La Rose Hotel, and the Western Hotel. Quarrying died out after horse-drawn wagons gave way to autos. Horses needed shaped stones to get a good footing on San Francisco's steep streets; auto drivers preferred smooth asphalt. (Courtesy of Mike Capitani.)

Quarry workers liked to relax in the cool interior of the Chiotti Brothers' Hotel Torino, here shown in 1909. The Torino, a boarding house for quarry workers and other Italian immigrants, was at the corner of Sixth Street and Adams. (Courtesy of the Sonoma County Museum.)

Five

MERCHANTS AND STOREFRONTS

Workmen fix the streetcar tracks in front of the Exchange Bank at the corner of Fourth Street and Mendocino Avenue, across from the county courthouse, sometime between 1901 and 1906. The bank, founded by Frank Doyle and his father, Manville Doyle, was on the ground floor. Dr. James Jesse occupied the corner office on the second floor. As the largest town in the valley, Santa Rosa became the banking center of central Sonoma County. As business increased, Santa Rosans built multi-story hotels for business travelers, and they opened stores patronized by town residents and local farmers. (Courtesy of the Sonoma County Museum.)

Work was steady in Cogan Brothers' Horseshoeing and Blacksmithing Works. E.P. Colgan ran the Santa Rosa House, located at the regular stagestop, in the 1850s. As the primary stagecoach halt between Petaluma and Cloverdale, it was the ideal place for both a hotel and a carriage works in the days before a railroad line. When the railroad did arrive, Colgan's sent a horse-drawn omnibus down to the depot to pick up guests. (Courtesy of the Sonoma County Museum.)

This blacksmith with the hammers, tongs, and anvil that were the tools of his trade worked at one of the downtown carriage works. In the first years of the 20th century, more and more Santa Rosans brought in autos for repairs instead of wagons. The most enterprising and farsighted blacksmiths and carriage makers learned to repair cars as well as buggies. (Courtesy of the Sonoma County Museum.)

Mrs. Dohn stands outside her notions shop in the 1880s. The store was also the office for Dohn's Express and Storage, although the warehouse was in a separate building on Wilson Street. (Courtesy of the Sonoma County Museum.)

Cnopius Feed and Grain operated as a kind of general store, offering coal, wood, butter, cheese, and eggs as well as animal feed and hay. Santa Rosa, as the principal town in the valley, supplied farmers in the surrounding region. Today a few businesses still specialize in animal feed, including Western Farm Supply on Seventh Street. (Courtesy of the Sonoma County Museum.)

Workers roll cigars at Moses Bower's Cigar Factory. Bower was elected mayor in 1902 but died in 1904, and Jay Bower, in foreground, took over the business. Moses Bower put his own picture on the lid of his La Santa Rosa cigars, c. 1895 (inset, upper left). (Courtesy of the Sonoma County Museum.)

Sidney Kurlander's shop sold handmade cigars—$3.50 for 100—as well as boxes of loose tobacco. (Kurlander Collection, courtesy of the Sonoma County Museum.)

Sid Kurlander was also an avid photographer who took photos of scenes and people in Santa Rosa, including his own delivery van. The ads for Fatima Cigarettes and Imperiales painted on the van prove that using vehicles to advertise is nothing new. (Kurlander collection, Sonoma County Museum.)

Electrician Hymie W. Jacobs, at left, checks out a big shipment of glass goods from General Electric with the assistance of a helper, at right, and a dachshund perched on the crates. Next door in the same building was A. Jacobs, tailor, probably a relative. (Courtesy of the Sonoma County Museum.)

A streetcar at lower right runs past the front of the Santa Rosa Shoe Factory. Once rail lines reached Santa Rosa in the 1870s, goods could easily be shipped to markets throughout the country. (J.H. Downing photo, courtesy of the Healdsburg Museum.)

Paul Hahman, at left in background, mixes a prescription while an assistant fills bottles at the Hahman Apothecary, c. 1920. Hahman was the son of Feodor Hahman, one of the founders of Santa Rosa. (Courtesy of the Sonoma County Library.)

Butcher Paul Noonan lived in the 700 block of Beaver Street and dressed carcasses for local hunters. His competitors were William Steinbring on Exchange Avenue, and William Wernecke and Walter Callahan on Mendocino Avenue. (Courtesy of the Sonoma County Museum.)

Certain businesses by their very nature require house calls. The town piano tuner, aptly named H.E. Medley, poses in front of his shop on the company motorcycle. (Courtesy of the Sonoma County Museum.)

The wagon from Pioneer Laundry made regular deliveries to businesses and hotels like the New Santa Rosa rooming house. (Courtesy of the Sonoma County Museum.)

Bertolani Bros. Grocery, with an early model delivery truck parked in front, sold produce and dry goods. (William McClearie photo, courtesy of the Sonoma County Museum.)

Charlie Traverso, at right in a white coat, sold cheese, wines, and local Grace Bros. ale at his grocery at Fourth and A Streets, June 1934. At left is J. Baumgartner, brewmaster for Grace Bros. Brewery. Traverso first went into business with Frank and James Arrigoni in 1932, but after five years the two families started separate businesses. Charlie's sons Enrico and Louis ran Traverso's Market for decades, and today their children run the store on Third Street. (Courtesy of the Sonoma County Museum.)

Bertoli Grocery, located on Third Street near the courthouse, sold produce and canned goods. From left to right are Romeo Bertoli, Elsie Bertoli, John Dent, Paul Bertoli, and Everett Bettencourt in 1924. (Courtesy of the Sonoma County Museum.)

As neighborhoods developed away from the center of town, so did corner mom-and-pop markets like Vinciguerra's at Ninth and Wilson Streets, run by Harry and Lillian Vinciguerra. The billboards advertise Royal Tires and Sea Island Sugar. (Courtesy of the Sonoma County Library.)

Ice cream vendor F. Benincasa brought his 5¢ ice cream cones to Santa Rosa youngsters on hot days. (Courtesy of the Sonoma County Museum.)

In 1919 Arthur and Mabel Corrick founded Corrick's gifts and stationery, one of Santa Rosa's oldest family-owned businesses, shown here in 1939. Their daughter, Marjorie Brown, inherited the business, and later her son Corrick Brown, who also conducted the Santa Rosa symphony, succeeded her. His son Keven now runs the Fourth Street store. (Courtesy of the Sonoma County Library.)

By the 1870s Santa Rosa was a regional center frequented by tradesmen and merchants, who stayed in downtown hotels. The Grand, built in 1873 and shown here in 1875 at Main and Third Streets, had 40 rooms and 13 suites. Stanley, Neblett and Juilliard's sold hardware on the ground floor. The hotel was hard hit in the 1906 quake: landlord Michael McDonough and his piano were shaken out of the building and onto the sidewalk. (J.H. Downing photo, courtesy of the Healdsburg Museum.)

The Occidental Hotel on Fourth Street, seen here in 1914, was built after an earlier version collapsed in 1906. Its cupola and archways have a Moorish flavor. Note Keegan Brothers clothiers on the ground floor. By the 1970s big downtown hotels were out of favor; the Santa Rosa Hotel closed in 1973, followed by the "Occi" in 1976. (Courtesy of the Sonoma County Museum.)

Brothers Frank and Joseph T. Grace, founders of Grace Bros. Brewery, donned tuxes along with Frank's sons Bill, Jack, and Tom, for a group shot of one of Santa Rosa's premier commercial families. Joseph T. Grace was a prime mover in the creation of Sonoma County Fair and served as its first president. (Courtesy of the Sonoma County Library.)

In 1897 brothers Frank and Joseph Grace bought the Metzger Brewery at Second and Wilson Streets. When it burned in 1898 they built a new four-story brewery and also bought Kroncke's Park, renaming it Grace Bros. Park and using it as a beer garden to boost sales. When this photo was taken in 1941, Frank's sons Jack, Tom, and Bill ran the business, which weathered Prohibition as an ice house. In the 1950s mildew devastated local hop crops, and improved machinery used on large scale hop operations in other areas made the small Sonoma County hop farm impractical. In the 1980s a new brewery, Xcelsior, made a short-lived attempt to revive the Grace Bros. label. (Courtesy of the Sonoma County Library.)

The staff of Pacific Telephone and Telegraph poses in front of their Fifth Street office, February 1922. From left to right are Mr. Nader, the wire chief; Mr. Hoppe, chief clerk; Molly, traffic stenographer; Ann, chief operator; unknown plant stenographer; Amy, the communications steno; Lena, the cashier; Elsie; Nell; Mr. McT____, district plant chief; Baird, the collector; and Mr. Van Tillow, manager. (Courtesy of the Sonoma County Museum.)

The more complex a new technology, the more complex its malfunctions. The advent of television meant the start of specialized repair shops like Dom's TV repair, seen here in 1958. (Courtesy of the Sonoma County Library.)

Radio was a new invention in 1922 when Armand Saare, center, started a repair shop in his mother's basement. He opened this shop on Mendocino Avenue in the 1930s, where he and employees John Abraham, at left, and Ernie Demond sold Zenith and Philco radios. Saare later moved the shop to Fifth Street and added TVs and fridges. He provided the public address system for the Sonoma County Fair and set up a sound system in Courthouse Square for the annual Rose Parades. (Courtesy of the Sonoma County Museum.)

Reporters for KSRO radio, the "Voice of the Redwood Empire," pose beside station cars in the 1960s. *Santa Rosa Press Democrat* publisher Ernest Finley started KSRO in 1937, despite fierce competition from San Francisco stations. The new station was on the top floor of the newspaper's Mendocino Avenue building and featured the KSRO Band, led by Vincent Trombley. Over the years many stations have enhanced the local arts and music scene, including the KZST, KRSH/The Krush, KVRE, the multi-lingual KBBF, and public radio's KRCB. Santa Rosa got its own TV station, KFTY-TV50, in 1972. (Don Meacham photo, courtesy of the Sonoma County Library.)

Santa Rosa businessman G.K. Hardt began selling autos in 1937. In 1952 his dealership at Oak Street and Santa Rosa Avenue was one of many on Santa Rosa's original auto row. While Santa Rosans still shop for cars on that stretch of Santa Rosa Avenue, most auto dealers have moved to the Corby Auto Mall at the south end of town. (Courtesy of the Sonoma County Library.)

Talmadge "Babe" Wood built his auto dealership, specializing in Reo trucks, in 1935 at the corner of Mendocino and Seventh Street. He later acquired the DeSoto and Plymouth franchises, and finally added Pontiacs and Cadillacs. In 1976 he moved the dealership to Corby Avenue to become part of the new auto mall. Now over 100 years old, Babe Wood still enjoys his annual birthday treat: piloting a small plane over the fields of Sonoma County. (Courtesy of the Sonoma County Library.)

With the end of World War II, private cars went into production again, and the buoyant postwar economy gave Santa Rosans the cash to buy them. The new 1949 Fords in this Santa Rosa showroom featured "Hydra-foil" front springs. (Courtesy of the Sonoma County Library.)

Darrold Parks hands the keys of the first convertible Carmen-Ghia sold at Veale Volkswagen to Dick From in 1958. (Don Meacham photo, courtesy Sonoma County Library.)

Restaurants were an integral part of Santa Rosa's downtown, since so many hungry commercial travelers stayed in its hotels. Campi Restaurant, run by "Little Pete," was on Third Street facing the courthouse, next door to J.W. Godfrey's Saddlery, sometime after the 1906 quake. W.E. Rushing, an architectural draftsman, was upstairs. (Courtesy of the Sonoma County Museum.)

Bert and Helen ran the popular Guidotti's Restaurant on the corner of Seventh Street and Adams, shown here in 1948, just down the street from Lena's Restaurant. Now the equally popular Michele's, in the same building, provides Santa Rosans with fabulous Italian dinners. (Courtesy of the Sonoma County Library.)

In the heart of the West Side's Italian neighborhood in the 1890s was the Battaglia Hotel, Olinto Battaglia's boarding house for immigrants. His daughter and son-in-law Lena and Alviso Bonfigli turned it into Lena's, a mainstay of Italian dining. In the 1930s Lena added a dance floor, and it became a popular nightspot. Soldiers and sailors frequented it during World War II, and KSRO broadcast from the dance floor on Saturday nights. Lena's son Kewpie ran the place after she died in 1973. When it closed in 1996, the site became Chop's, the DeMeo Teen Center, built with the millions bequeathed by Charles "Chop" DeMeo, a former mayor and parks commissioner who died in 1995. (Courtesy of the Sonoma County Library.)

Chonne Patton and Ken Minyard share a banana split in 1959 at Gordon's Drive-in. Started as Quinley's in 1947 where College Avenue meets Fourth Street, it became Gordon's in 1950, a popular hang-out for Santa Rosa teenagers to devour hamburgers and sip cokes. Gordon's was not a drive-through hamburger stand. Customers parked and rolled their windows halfway down so the car-hop could clip on a horizontal tray loaded with burgers and fries. Later the spot became the Captain's Table, which closed in 1992. In 1995 Al Cooper, grandson of the original Quinley's, revived the drive-in at Fourth Street and College Avenue. (Don Meacham photo, courtesy of the Sonoma County Library.)

Ceci Payne, seen at far left, and others leave the Topaz Room on Hinton Avenue in 1959, after a show of the latest fashions from her Franklin Avenue shop. The Topaz Room opened in the 1940s and was the fanciest place in town to eat out. It closed in the 1980s. (Don Meacham photo, courtesy of the Sonoma County Library.)

Press Democrat editor Ernest J. Finley, seated at right, and circulation manager Kenneth Brown discuss business in 1930. The *Sonoma Democrat* was started in 1857; rancher John Taylor was the first subscriber. Finley purchased it in 1898, combining it with his weekly, the *Santa Rosa Press*. The *Santa Rosa Republican* was Finley's chief competition until he purchased it in 1927. The *Press Democrat* remains the North Bay's major daily paper. Its prestige reached new heights in 1997 when photographer Annie Wells won a Pulitzer for her photo of a rescue from a raging creek. At lower right is that mainstay of 20th century technology, the typewriter. (Courtesy of the Sonoma County Library.)

The *Press Democrat* occupied the 500 block of Fifth Street in 1909, when this photo was taken; today it is on Mendocino Avenue. Other town newspapers ranged from the Italian-language *Echo de Santa Rosa*, published in the 1880s for the town's Italian community, to the *Santa Rosa News Herald*, a weekly that folded in 1988. (Courtesy of the Sonoma County Library.)

Early 20th century clothiers evolved into the more comprehensive department stores. Shown here is the staff of the White House assembled at the store's corner entrance in 1911. (Courtesy of the Sonoma County Library.)

By the 1940s the White House, at Fourth and B Streets was a major downtown department store. Farther east on Fourth was Wright's Fountain, Trend o' Fashion, and Hall Brothers Drugs. In the distance are the five-story Rosenberg Building and the tower of Rosenberg's (now Barnes and Noble). (Courtesy of the Sonoma County Library.)

One year after a 1936 fire destroyed Rosenberg's Department Store, Fred Rosenberg, son of founder Max Rosenberg, built a streamlined Art Moderne style store. The McNeany family bought it in 1951 and ran it for another 37 years before closing in 1988. In 1993 the City approved the building's demolition. The Sonoma County Historical Society appealed, blocking the wrecking ball. Soon after, Barnes and Noble agreed to move in, completely restoring and renovating the downtown landmark. (Courtesy of the Sonoma County Museum.)

Six

CIVIC DUTY AND A PORTABLE POST OFFICE

As Santa Rosa grew into a bigger town and finally a regional center, citizens found themselves cast in the roles of county sheriffs, police officers, and firemen. Civic institutions became more specialized, requiring trained doctors, teachers, librarians, and postal workers. Here Sheriff E.P. Colgan poses with the Sonoma County posse in 1888. From left to right are Deputy Hy Groshong, Deputy M.V. Vanderhood, Undersheriff J.F. Naughton, Sheriff Colgan, and jailer Louis Breitenbach. George Matthews, who grew up on a farm in Rincon Valley and worked as a blacksmith for Colgan Brothers Carriageworks, joined the Santa Rosa force in 1909 and took over as chief in 1918. (Courtesy of the Sonoma County Library.)

The Sonoma County Sheriff's staff in 1939 included, from left to right, (front row) Matron Grace Bixby, an unidentified deputy, Sheriff Al Wilkie, Stuart Rich, and John Ellis, who would later become sheriff himself; (back row) the jailhouse cook, Deputy Early, Primo Rocco, William Barnett, Paul Noonan, and unknown deputy. (Courtesy of the Sonoma County Library.)

Sheriff James "Sunny Jim" Petray was a popular Sonoma County sheriff whose murder in 1920 led to one of the last lynchings in the West. Petray and two other officers went to arrest three fugitives holed up at a house on the west side of town. The criminals killed all three peace officers but other officers quickly rounded them up. Five nights later, over 200 vigilantes took the trio from the jail and hanged them. Decades later a participant, young at the time of the lynching, revealed the details to *Press Democrat* columnist Gaye LeBaron: deputies at the jail handed the cell keys to vigilantes from Healdsburg, who came to avenge the death of their friend and neighbor. (Courtesy of the Sonoma County Library.)

Popular Santa Rosa Police Chief, Melvin "Dutch" Flohr, at left, and "Chappie" Chapman, the owner of Foley and Burk's Midway, at right, check out the lights for the midway at the summer fair in 1958. Flohr was only 31 and had only been chief of the Healdsburg Police Department for a year when Santa Rosa hired him to head its own police department. A Petaluma native, Flohr replaced former Chief Watson Maxwell at a salary of $225 a month. He became a popular long-time chief, retiring in 1974. (Don Meacham photo, courtesy of the Sonoma County Library.)

Where there is a courthouse, paperwork is bound to pile up. There to handle it were County Clerk F.L. Wright, Chief Deputy George W. Libby, Deputies J.W. Ford, G.A. Feldmeyer, and B.F. Ballard. (Courtesy of the Sonoma County Museum.)

Santa Rosa firemen pose proudly with their engine, c. 1924. Third from left is T.W. Stump. Starting in the 1860s, Santa Rosans relied on rival volunteer companies that tried to outdo each other in putting out fires. In 1894, Frank Muther, a cigar-maker and head of volunteer company #1, convinced the city council to fund an official Santa Rosa Fire Department. In 1896 the town bought its first steam fire engine, an American LaFrance. (Courtesy of the Sonoma County Library.)

The May 1936 conflagration that destroyed Rosenberg's Department Store at Fourth and B Streets was one of the town's more spectacular fires. It also damaged the nearby Santa Rosa Hotel and Reed's Millinery Shop. Here Santa Rosa firemen inside the store attempt to quell the flames; the two in front have their helmets on backwards, probably as protection against the intense heat. Despite the profession's inherent danger, the SRFD's first fatality did not occur until 1966, when firefighter John Hurt was killed in a fire at Santa Rosa Upholstery on Third Street. Locals raised $4,000 for his widow and five children. (Courtesy of the Sonoma County Museum.)

Santa Rosa Fire Department officers and trucks line up by the courthouse on Fourth Street, with Hinton Avenue in the background in 1939. The fire department was on Fifth Street, where the parking lot behind Portofino's Restaurant is today. In 1940 the main station moved to 415 A Street, and the growing town got its first substation on Benton, as well as its first ambulance. (Courtesy of the Sonoma County Library.)

Fireman George Sampson gets some much-needed oxygen after helping to fight the blaze at Rosenberg's store in May 1936. The following year, store owner Fred Rosenberg, son of Rosenberg's founder Max Rosenberg, had a gleaming new store built at the corner of Fourth and D Streets, a building that now houses Barnes and Noble bookstore. (Courtesy of the Santa Rosa Fire Department.)

Santa Rosa firemen battle a blaze at Montgomery Village in 1953. On the right is Al's Village Repair. (Courtesy of the Sonoma County Library.)

Kids read in the children's basement reading room of the downtown library in 1925. Dagny Juell, the children's librarian from 1922 to 1959, steered generations of young Santa Rosans toward the world of books. The children's room in the new 1966 library was named in her honor. (Courtesy of the Sonoma County Library.)

Librarian Jan van Schuyver teaches kids to work with paper at a workshop at the library at Third and E Streets, built in 1966. (Don Meacham photo, courtesy of the Sonoma County Library.)

Santa Rosa's new main library at Third and E Streets replaced the previous stone library. Items packed into a time capsule in the cornerstone of the new structure include the city charter, a town map, a ribbon from the dedication of the 1905 library (which was destroyed in the 1906 quake), and a letter dated 1903, praising town librarian Anna Bertha Humli. (Courtesy of the Sonoma County Library.)

In the early 1900s Santa Rosa doctors treated patients in their offices; the county hospital was for indigent patients. The private Mary Jesse Hospital, which became the Tanner Hospital in the 1920s, treated acute illnesses. Sonoma County Hospital, shown here in 1942, opened in 1937, when Santa Rosa's population was around 12,000. In the 1990s it became Sutter Hospital. (Courtesy of the Sonoma County Library.)

After World War II, Santa Rosa's rapid growth prompted calls for an additional hospital. The City selected a spot on the far side of Santa Rosa Creek, where a cherry orchard stood. After a vigorous fund-raising campaign, Memorial Hospital celebrated its opening, shown here on January 1, 1950. The City delegated the administration of the hospital to the Catholic Sisters of St. Joseph of Orange, who still operate it today. The City also built a traffic bridge across Santa Rosa Creek at what is now Montgomery Drive, connecting the new hospital with the center of town. (Courtesy of the Sonoma County Library.)

Youngsters learn lifesaving at the Santa Rosa Municipal Pool on King Street in 1954. The pool, which opened in 1925, was built with funds raised by the Santa Rosa Playgrounds Association and was designed to replace an older swimming pool, the A Street Plunge. (Courtesy of the Sonoma County Library.)

An instructor teaches young swimmers proper diving form at the Santa Rosa Municipal Pool on King Street in 1954. In the 1920s the Playgrounds Association urged the City to form a parks commission. Acquiring the site of the town's first public school, Fremont Grammar School, the City used it to build Fremont Park between Fourth and Fifth Streets. In the 1930s they added Juilliard Park and DeMeo Park. Today a much larger City of Santa Rosa maintains a variety of parks, including Howarth Park in Bennett Valley, and the Finley Swim Center on Stony Point. (Courtesy of the Sonoma County Library.)

Along with much of Santa Rosa's downtown, the post office was demolished in the 1906 earthquake, and postal workers had to make do with a temporary shack. Meanwhile brothers Frank and Henry Hoyt, prominent builders in post-quake Santa Rosa, began to construct a magnificent new post office at Fifth and A Streets. Note the tower of the Empire Building and the top of the new courthouse in the middle distance above. At left one of the builders contemplates progress on the new post office, which was completed in 1910. (Courtesy of the Sonoma County Museum.)

Workmen pause at the construction site of the new post office on Fifth Street in 1910. (Courtesy of the Sonoma County Museum.)

Mailman Ross Fouts takes the wheel of a postal truck next to the 1910 post office. Ironically, the post office building later became the Sonoma County Museum, which houses these post office photos. (Courtesy of the Sonoma County Museum.)

When the new post office was finished in 1910, it was one of the finest buildings in the North Bay. Built with Indiana Buff Bedford limestone and designed by architect James Knox Taylor, it served as Santa Rosa's post office until 1966, when a new post office opened. The City took over ownership of the building in 1976. (Courtesy of the Sonoma County Museum.)

Santa Rosa Post Office employees, several of whom wear caps with the official round emblem, pose for a picture c. 1915. (Courtesy of the Sonoma County Museum.)

Substantial civic buildings normally stay put until they fall to the wrecker's ball. But in 1979 Santa Rosans watched in fascination as their 1,700-ton Fifth Street post office made the laborious 900-foot journey—at the rate of 20 to 30 inches a day—to 425 Seventh Street. After some last minute touching up, at right, the historic edifice assumed its new duties as the Sonoma County Museum. SCM was the brainchild of the Museum Foundation of Sonoma County, which envisioned it as a history museum with room for cultural exhibits and community projects. (Courtesy of the Sonoma County Museum.)

91

Staff and supporters gather around the newly installed Sonoma County Museum for the opening ceremonies. The words on the awning of the horse-drawn buggy are "Museum Today!" At the start of the new millennium, the museum was working on plans to expand into a Seventh Street cultural campus. (Courtesy of the Sonoma County Museum.)

Once the new Sonoma County Museum was in place, relieved and tired volunteers posed at the new site. Their shirts read, "They said it couldn't be done!" In back are architect Dan Peterson and Tom Golden. In front, left to right, are Gerry Peterson and Toby Smith. Peterson was instrumental in having the building added to the National Register of Historic Places as one of the state's few remaining examples of classic federal architecture. Golden was a real estate broker who worked closely with Christo and Jeanne-Claude, who created the 1976 Running Fence project. Shortly before he died in 2002, Golden donated his extensive collection of Christo memorabilia to the museum. (Courtesy of the Sonoma County Museum.)

Seven
THE CALL OF WAR

Company E was the Santa Rosa unit of the state militia, a precursor of the National Guard. During the Spanish-American War, Santa Rosa lads joined Co. E, hoping to fight the Spanish Empire in the Philippines, but the war ended before they got any closer than San Francisco, Most of their duty was spent at Camp Barrett in Oakland, where these Santa Rosans pose with their rifles in 1898 (note the "E" at the peak of the tent). Standing, from left to right, are Will Kidd, Sam Lewis, and Paul Coulter. Seated left to right are Sam Clark, Frank Brown, and Will Godman. (Courtesy of the Sonoma County Museum.)

Families gather at the Southern Pacific Depot on North Street to cheer for departing troops during World War I. The Southern Pacific Depot was the terminus of the rail line from Sonoma. Below, troopers of Santa Rosa's Company E gather in the mess tent c. 1917. (Courtesy of the Sonoma County Library.)

Recruits training for duty in World War I line up outside the Sonoma County Courthouse, while courthouse employees watch from the windows. (Courtesy of the Sonoma County Museum.)

Hilliard Comstock, seen here on the left, was commander of the Santa Rosa unit that fought in World War I. He and a fellow officer stand more or less at attention in front of the Sonoma County Courthouse. Of the Sonoma County men who fought in France, 37 died in action. (Courtesy of the Sonoma County Museum.)

Everyone pitched in to raise both money and morale in support of the war effort. Here women in camouflage line Fourth Street to promote a fund-raising drive. Over 240 Sonoma County servicemen and women died in World War II, but sadly the toll did not end there. Ninety from Sonoma County—29 from Santa Rosa—died in the Vietnam War. (Courtesy of the Sonoma County Museum.)

Mechanics Vern Srager, on the left, and R.C. McClintock were among the large ground crew that kept the planes in condition for their training flights at Santa Rosa Army Air Field north of town. During the Korean War, pilots were busy training at the Naval Air Station near Todd Road. It later became the private Tollefson Airport, and today its buildings are used as artists studios and offices. (Courtesy of the Harrison Rued Collection.)

People crowded onto the grounds of the Santa Rosa Army Air Field to get a glimpse of the new P-59, the first jet-propelled fighter plane, on August 1, 1945, unaware that within days the war would be over. (Courtesy of the Harrison Rued Collection.)

Temple Smith, a captain in the Army Air Corps, was first stationed in Santa Rosa and later served in Europe. After the war he went to Santa Rosa Junior College where he met his wife, June, then transferred to the University of California at Berkeley. Later he worked in the insurance business. Both are now active in local historical societies, and Temple is a trustee emeritus of the Sonoma County Museum. (Courtesy of June and Temple Smith.)

After World War II America turned its attention to the needs of civilian life and retooled many war-related enterprises to serve the public. The less-than-elaborate Sonoma County Airport, shown here in 1947, expanded to serve an aviation-oriented public. On display here is a P-38. Today business parks line Airport Boulevard between Highway 101 and the airport, but the land west of the airport is still largely rural. (Courtesy of Harrison Rued.)

This 1940s view from the control tower shows the Santa Rosa Army Air Field north of Santa Rosa with fields and eucalyptus trees in the background. In July 1946 the airfield was turned over to the county and became the Sonoma County Airport. In 2000 the airport was renamed Charles Schulz Airport, in honor of the late cartoonist, a long-time Santa Rosa resident. (Courtesy of Harrison Rued.)

Eight
WHOOPING IT UP

In the days before mass media Santa Rosans created their own entertainments through clubs, parades, fairs, and amateur orchestras and theatricals. Parades and fairs served a two-fold purpose, providing entertainment and giving local ranchers and business people a chance to promote their products. This c. 1901 photo of a parade on Fourth Street, possibly on the Fourth of July, shows downtown as it looked prior to the earthquake. Note the decorated archway advertising Grace Bros. Brewery. (Courtesy of the Sonoma County Museum.)

The Bees, an early 20th century women's group, had a Santa Rosa chapter, #33, shown here dressed for a meeting in 1910. (Courtesy of the Sonoma County Library.)

Contractor Victor Durand (in black hat) and architect Brainerd Jones (in light suit) brought the building plans to the August 17, 1908 groundbreaking of the Saturday Afternoon Club, an upscale women's club at Tenth and B Streets. In the days before mass entertainment, people were great joiners, forming lodges and clubs for social activity as well as charity work. The club was not limited to social affairs; it served as a hospital during the winter of 1918–1919, when the worldwide influenza epidemic struck Santa Rosa. Today the building is part of the St. Rose Walking Tour. (Courtesy of the Sonoma County Museum.)

Santa Rosa's 33 Degree Masons, some of the town's most prominent men, pose in their resplendent uniforms. They are, from left to right, (front row) C.A. Belden, Dr. Meneray, Walter Davis, Louis Murdock, W.A. Arnold, Mr. Rhodes; (middle row) A.B. Lemon, Frank Loomis, Judge Crawford, A.B. Ware, W.V. Dogget, Ned Neblet, and Capt. Guy Grosse; (back row) Judge Ross Campbell, H.L. Tripp, Frank Laughlin, Colonel McDonald, Dr. Wright, Walter Good, B.N. Spencer, Frank Herke, and John Taylor. (Courtesy of the Sonoma County Museum.)

In 1922 a women's group borrowed $4,000 to build a social hall on West College Avenue. When the club sold Monroe Hall in 1977, it became a venue for classes and square dancing. Another clubhouse, north of town in Franklin Park, was built in 1953 when neighbors organized to pull down a dangerous abandoned sawmill. At no cost to the city, the 150-member Franklin Park Association built a clubhouse of redwood and Douglas fir, working on Sundays. At its completion they gave the new recreation center to the City for all its residents. (Photo by Simone Wilson.)

The Soroptimist Club, one of Santa Rosa's most active clubs, is shown here at a get-together in the 1940s. (Song Wong Bourbeau Collection, courtesy of the Sonoma County Museum.)

Fund-raisers are the heart and soul of many clubs. KSRO announcer Jim Grady, with microphone, interviews Craig Johnston, president of the Active 20-30 Club, about their annual game with the Santa Rosa Jaycees. The 1972 game brought in $600, which went to the Police Youth Activity Fund. (Courtesy of the Sonoma County Library.)

Thomas Keegan started Santa Rosa's Rose Parade in 1894. Early entries were simply wagons and autos decked with blossoms, like this 1922 entry from the Assessor's Office with Peggy Terwilliger, Minerva Salisbury, and Thelma Strom. (Courtesy of the Sonoma County Museum.)

These small Rose Paraders in 1907 are, from left to right, Elizabeth Thompson, Catherine Pressley, Dorothy Seawell, and Queen Geraldine Grace. For 12 years, the festival had only juvenile courts. Adult Rose Queens returned in 1908. (Courtesy of the Sonoma County Museum.)

"Uncle Sam" Mason waits for mail truck driver Ross Fouts to catch up in the 1931 Rose Parade. The parade has continued to the present with gaps for the 1906 quake, the Great Depression, and both World Wars. The first parade, in 1894, was a qualified success: the car carrying the king and queen was rerouted down side streets because their thrones were too high to clear the electric and telephone lines. (Courtesy of the Sonoma County Museum.)

Merchants and civic organizations sponsored floats like this windmill entry from the Santa Rosa Flour Milling Co. (Sandborn Collection, courtesy of the Sonoma County Museum.)

Santa Rosa's Campion Drill Team in their snappy striped shirts was a highlight of annual parades. Here they are marching through the intersection of Fourth and D Streets, with Farmer's Drugs on the corner, and Kress' Dime Store in the background. (Courtesy of the Sonoma County Museum.)

Posing with Robert Ripley's DeSoto in 1932 are, from left to right, Finlaw Geary, George Proctor, Don Gray, David Ayers, Lemuel Ayers, Robert Ripley, and Walter Nagle. Born in Santa Rosa in 1893, Ripley dropped out in his senior year to pursue cartooning. In 1918 he created the "Believe It Or Not" column featuring the odd and the grotesque. The column, carried in 325 papers in 33 countries, made him world famous. Although he lived most of his adult life in New York, he was buried in Santa Rosa when he died in 1949. (Courtesy of the Sonoma County Library.)

Although Santa Rosans organized a variety of fairs as early as 1855, the Sonoma County Fair was created in 1936 when the board of supervisors set up a fair district with a 30-member board. Joseph Grace served as president and Emil Kraft as fair manager. Horse racing was the economic engine driving the fair, with six races a day. Admission was 50¢ for adults, and a dime for kids. (Courtesy of the Sonoma County Fair.)

Autos also raced at the fair's track. During the April 1939 Tin-Lizzie Derby, two jalopies locked wheels and crashed; 17 more cars piled into them, leaving a tangle of fractured metal. Police cars and ambulances raced to the track to rescue the injured drivers, all of whom lived to race again. (Courtesy of the Sonoma County Library.)

The fair went on as usual in 1942 despite the war, with three extra days of horse racing to benefit the USO. The army took over the fairgrounds in 1942 and cancelled the 1943 and 1944 fairs. The fair started up again in 1945 and has continued ever since. Besides racing, the fair offered an air carnival, flower show, winery displays, livestock judging, bands, and the Foley and Burke midway. Santa Rosans gathered at the county fair racetrack in August 1953 to honor Lou Dillon, a trotter bred by Frank and Ira Pierce at their stock farm, which later became the Fairgrounds Track and Stables. Born in 1900, Lou Dillon was sold to an Ohio entrepreneur when Henry Pierce died in 1903. Within the year the horse made history in Readville, Massachusetts, as the first trotter to break the two-minute mile. The young women are holding a bronze plaque dedicated to Lou Dillon and the young man is holding a photo of him. (Courtesy of the Sonoma County Fair.)

The Sonoma County Fair also gives local organizations a chance to reach out to the public. Inside the pavilion during the 1959 fair, members of Burkart's Junior Dance Academy scout for new members. Bob Burkart taught the art of social dancing to generations of Healdsburg and Santa Rosa youngsters. (Don Meacham photo, courtesy of the Sonoma County Library.)

San Francisco's Caledonian Club called the Scottish clans together every year for the Highland Games, held at the Sonoma County Fairgrounds on Labor Day Weekend. The games, with bagpipes, dancing competitions, and feats of strength like the caber toss and the stone toss, shown at left in 1985, were held in Santa Rosa for 32 years. After the 1993 games—the 127th annual—the Caledonian Club relocated its event to Pleasanton. (Photo by Simone Wilson.)

The Grape Stomp—followed by showers for participants—is the most colorful event of the annual Harvest Fair, founded in 1976 and held every autumn at the Sonoma County Fairgrounds. The fair features local wines and other crops and provides a showcase for local artists. (Courtesy of the Sonoma County Fair.)

Conductor Corrick Brown leads a 1962 rehearsal of the Santa Rosa Symphony. In 1958 Brown took over from symphony founder George Trombley and led the group for nearly 40 years. Jeffrey Kahane took over in 1996. The symphony performed at Santa Rosa High until the Luther Burbank Center opened in 1982. Symphony boosters were worried about filling the 1,500-seat LBC auditorium, but cars headed for the opening performance jammed Highway 101 for three miles. (Don Meacham photo, courtesy of the Sonoma County Library.)

Dr. Jack Williams holds one of the free mouth guards he made for the players of the Redwood Ice Arena hockey team in 1971. Santa Rosa's first skating rink, built by the Grace Brothers at their brewery in the 1930s, was the venue for Santa Rosa Junior College's hockey team. Before World War II, Canadian students flocked to SRJC, catapulting the Polar Cubs hockey team into contention with major teams like USC and UC Berkeley. Skating became popular again in April 1969, when Charles Schulz opened the Redwood Empire Ice Arena with a guest appearance by Olympic skating gold medalist Peggy Fleming. Locals often spotted the world-famous cartoonist in the arena's coffee shop, which he named "The Warm Puppy." (Don Meacham photo, courtesy of the Sonoma County Library.)

Santa Rosans pursued dramatics as well as music. Cast members of Gilbert and Sullivan's *Mikado* in 1915 included W.C. Grant, Madeline Cowan, Amelia Kinslow, Earl Fulwider, Gwen Overton, Esther Scott, Elsie Pederson, Harold Loughery, and Katherine Miller Van Fleet. (Fulwider Family Collection, courtesy of the Sonoma County Museum.)

Beauty pageants were popular in the 1950s and 1960s, and every year Sonoma County sent its chosen selection to the statewide Miss California Contest. In 1959 Chonne Patton arrives at the state finals in Santa Cruz in an official pageant 1959 Ford Fairlane convertible. Under the sponsorship of the Santa Rosa Jaycees, Santa Rosa hosted the Junior Miss contest in the 1970s. (The pageant itself began in 1958.) In 1974 movie director Michael Ritchie came to film *Smile*, a parody of the Junior Miss competition, in the original's real-life host town, Santa Rosa. (Don Meacham photo, courtesy of the Sonoma County Library.)

Santa Rosa Junior College drama students get pointers during a 1966 rehearsal. From left to right are Donovan Jeffry, Kristine Unsicker, Don Tarpley, Pat Fisher, Wendy Tassman, Pat Landsdowne, Marjorie Shears, Almavida Rayos del Sol, and Jodi Lowder. (Courtesy of the Sonoma County Library.)

Santa Rosa has been blessed with top-notch theatre troupes, including Actors' Theatre, Santa Rosa Players, and the annual Summer Repertory Theater, which started in 1971. Actor/playwright Mollie Boice, here in her SRJC Theater Arts office with an unnamed friend in 1986, has been a mainstay of the local theater scene for over a quarter century. (Photo by Simone Wilson.)

Nine

MAD ABOUT THE MOVIES

Santa Rosans love going to the movies and sometimes find themselves in one. Several residents had parts in Alfred Hitchcock's 1943 thriller *Shadow of a Doubt*, filmed almost entirely on location in Santa Rosa. Hitchcock, seated here in foreground in a dark suit, directs a scene next to the NWP Depot. To the right of "Hitch" is Henry Travers, holding a white hat, and Teresa Wright; to his left is star Joseph Cotten. La Rose Hotel is in the right background. A Santa Rosa grocer's daughter, Edna Mae Wonacott, earned a supporting role as the heroine's precocious kid sister. Scenes were shot all over town, including the library, the 'Til-Two Bar, and a home on McDonald Avenue. (Courtesy of *Santa Rosa News Herald* archives.)

Before the era of big movie palaces, smaller storefronts served as "theaterettes," showing silent films and newsreels. The Crone Brothers' Columbia Theater was part of the Carithers Block. Playing that day was a newsreel called *Daredevil Aviators*. (Courtesy of the Sonoma County Museum.)

The California Theater on B Street, shown here in 1945, was originally the G & S, built in 1923. After the twin earthquakes of October 1969, the Cal, the courthouse, and several other buildings were declared unsafe and torn down. Some citizens, who felt the demolition was an underhanded way of clearing space for new development, formed the Save the Cal Committee in 1974. They tried, but failed, to exempt the Cal from the City's urban renewal plan. The theater was torn down in 1977, but its vintage Wurlitzer organ escaped demolition and went to the American Theater Organ Society in San Diego. (Courtesy of the Sonoma County Library.)

A crowd mobbed the Roxy Theater on B Street in 1936 to vie for a $350 prize. Moviegoers purchased their popcorn for 5¢ at Wolcott's, just left of the entrance. Originally called the Cline, the Roxy was damaged in the 1969 quake and subsequently torn down. In 2000, Dan Tocchini Jr., whose father once owned Santa Rosa's Strand Theater, opened the 14-screen Roxy at the corner of First Street and Santa Rosa Avenue. (Courtesy of the Sonoma County Library.)

The Tower Theater at 730 Fourth Street opened in October 1939 with a showing of *The Man in the Iron Mask*, starring British swashbuckler Louis Hayward. Built by Fred Rosenberg near his department store of the same name, the Art Moderne theater boasted a 30-foot glass tower that echoed the tower of its taller Art Moderne neighbor, now Barnes and Noble bookstore. Its loge seats slid back and forth, and the murals inside showed scenes from the 1939 New York World's Fair. Unlike the Cal, the Tower had no stage; it was designed purely for showing movies. The Tower closed in 1959. (Courtesy of the Sonoma County Library.)

115

Santa Rosa's Free Public Library appears to be going up in flames during a scene from *Storm Center*. Daniel Taradash's 1956 drama starred Bette Davis as a librarian accused of being a Communist after she refuses to remove a controversial book from the library shelves. Off the set, Ruth Hall, Santa Rosa's real librarian, gave Davis a few professional pointers. (Photo by John LeBaron.)

Columbia Pictures shot *Storm Center* in the downtown library at Fourth and E Streets, as well as at the city council chambers, where 100 would-be actors tried out for bit parts. Several dozen local kids appeared in the final film, which also co-starred actress Kim Hunter (left). Santa Rosa was chosen because, as assistant director Carter De Haven said, "We were looking for a small city and this is the nicest small city we found." (Photo by John LeBaron.)

In 1948 a small production company that made locally-commissioned films made a short promotional film about Santa Rosa itself, focusing on the city council, the Santa Rosa Chamber of Commerce, and highlights of the downtown. The finished product, entitled *Santa Rosa Our Home Town*, enjoyed an occasional local revival; it played at the California Theater (above) in the 1970s. The film, roughly 45 minutes long, probably exists on 16 millimeter film somewhere in an archive. It does not have the world's most exciting plot, but it is a snapshot of Santa Rosa as it was in the years just following World War II. (Courtesy of Ripley Wilson.)

A camera crew prepares a scene for the 1991 remake of *Shadow of a Doubt*; Diane Ladd, in a black coat, stands on the porch of a McDonald Avenue home (right). Santa Rosa, with its stately Victorian architecture, has long been a popular location for films and commercials. Burt Lancaster and Edward G. Robinson starred in Arthur Miller's *All My Sons* (1948), filmed at the Grace home on McDonald Avenue. Other films shot here include The *Happy Land* with Natalie Wood (1943), *The Fighting Sullivans* (1944), *Pollyanna* (1960) with Hayley Mills, shot at the McDonald Mansion, and *Steelyard Blues* (1973), partially filmed at Juilliard Park. The latest was *Cheaper by the Dozen* with Steve Martin (2003), shot partly in Railroad Square. (Photo by Simone Wilson.)

Hollywood invaded McDonald Avenue for the 1991 made-for-TV remake of *Shadow of a Doubt*, with Mark Harmon as the evil Uncle Charlie and Diane Ladd as his small town sister. The filmmakers chose a different McDonald Avenue house than the one Hitchcock used. But this time the moviemakers shot their downtown scenes in Petaluma because traffic noise from Highway 101 was too intense in downtown Santa Rosa. (Photo by Simone Wilson.)

Tri-Star productions took over Santa Rosa High School, Lena's Restaurant, and other spots for the filming of *Peggy Sue Got Married* in 1986. Peggy Sue (Kathleen Turner), a 40ish mom, finds herself back in high school, revisiting the choices that shaped her life. Here Peggy Sue has a late-night chat with the class beatnik (Kevin O'Connor). Films and commercials are still being shot in the area and the Visitors Center in the depot in Railroad Square sells a map that shows where movies were shot locally. (Courtesy of Tri-Star Pictures.)

118

Ten
GROWING A FUTURE

At the start of World War II, Santa Rosa had only 12,000 inhabitants but was poised for a half-century of rapid growth. Here convertibles cruise past the courthouse on Admission Day, 1947. The billboard urges Santa Rosans to contribute to the construction fund for Memorial Hospital. On the right is the Empire Building on Exchange Avenue, housing the Bank of America. Originally the Santa Rosa Bank Building, the Empire Building, with its gilded Neo-classic clock tower, is one of the town's most recognizable landmarks. (Courtesy of the Sonoma County Library.)

Santa Rosa missed the wartime industrialization that transformed cities closer to the Bay; by the end of the 1940s the town still had only 17,000 residents. But World War II had set in motion forces for rapid growth. In 1948 developer Hugh Codding built the Town and Country Center, selling it the following year to finance an even bigger dream at the corner of Montgomery and Farmers Lane. His shopping center at Montgomery Village (above) opened in 1950 to serve a new development of over 3,000 homes, mostly built by Codding himself. The development was named for Billy Montgomery, a Santa Rosa sailor killed at Pearl Harbor. (Don Meacham photo, courtesy of the Sonoma County Library.)

Santa Rosa annexed the 900-acre suburb in 1951, boosting the town's population from 17,000 to 31,000. Hugh Codding was a former Navy Seabee who focused his construction expertise on building houses to FHA specifications. Here he is shown with Cecille Payne at the opening of her Town and Country dress shop in 1960. Codding's homes went up in record time; as a publicity stunt, he put up one house in three hours and nine minutes. By the mid-1950s, Codding Enterprises was the largest California real estate firm north of San Francisco. Santa Rosa continued to outpace other county towns. By 1970 it had 48,000 people, and in 2000 it had jumped to nearly 140,000. (Courtesy of the Sonoma County Library.)

With growth came the prosperity of the 1950s and 1960s. Crowds turned out for a new model car preview *c.* 1960. Santa Rosans opened the car doors, peeked under the hoods, and sat on cushy new upholstery with dreams of driving around town in style. The view is from Fourth and B Streets, looking eastward, with the Santa Rosa Hotel on the right. And for those without automobiles of their own, utilitarian Yellow Cabs (below) were poised to take Santa Rosans all over town to visit or shop. (Don Meacham photo above; both courtesy of the Sonoma County Library.)

121

Wrecking crews demolish the Sonoma County courthouse in 1970. The magnificent 1910 building was damaged in the 1969 earthquake, and city fathers decided to scrap it. The resulting space became known as Old Courthouse Square. Hinton and Exchange Avenues vanished, and Mendocino Avenue bisected what had once been the centerpiece of Santa Rosa's downtown. By 2004, citizens were discussing whether to reunite the two halves of the square and have a central plaza once more. (Courtesy of the Sonoma County Library.)

Henry Trione, Sonoma County's first mortgage banker as well as the founder of Empire College, at center with his sons Vic (right) and Mark, also played a key role in establishing Annadel State Park, 5,000 acres of oak woodland, marsh, and meadow just east of town. During crucial stages of fund-raising, Trione provided funds that guaranteed the park would become a reality. (Courtesy of the Trione family.)

Joe Coney, shown here in the 1930s, was a multi-millionaire with far-flung business interests. He owned silver mines, vast ranches, and a fleet of oil tankers. In 1934 he bought the 3,200-acre Annadel Farms from the Hutchinson family. Coney and his wife, Ilsa, bought surrounding parcels until they owned about 5,000 acres. The northern end of the property later became the Oakmont and Wild Oak developments. Most of his ranch is today's Annadel State Park. The park's Lake Ilsanjo, created by the Coneys, is an amalgam of their first names: Ilsa and Joe. (Courtesy of Karen McCarthy Price.)

Once a vital part of Santa Rosa's downtown, lower Fourth Street and the Northwestern Pacific Railroad Depot area languished after Highway 101 cut the town in half in 1948. In the 1970s, merchants and building owners infused new life and cash into the rundown neighborhood, which became the Railroad Square Historic District. After cartoonist Charles Schulz died in 2000, a statue of his Peanuts characters Charlie Brown and Snoopy went up in his honor in Depot Park. In the background is the Aroma Cafe. (Photo by Simone Wilson.)

In 1979 Railroad Square was placed on the National Register of Historic Places. Visitors window-shop on Fourth Street in 2004 with the freeway in the background. (Photo by Simone Wilson.)

Today Fourth Street between Wilson and Davis Streets is one of the city's most vibrant shopping areas, with boutiques and restaurants like Ristorante Capri, in the old Jacobs building, shown here in 2004. (Photo by Simone Wilson.)

Raford Leggett, Ig Vella, and Harry Lapham chat in front of the Western Hotel in historic Railroad Square c. 1980. The original 1880 Western Hotel burned down in 1903. The rebuilt stone hotel weathered the 1906 quake and is one of four historic quarried stone buildings on the square. The Northwestern Pacific Depot became the town's Welcome Center in 1997; the Northwestern Pacific Historical Society maintains a railroad exhibit there in the renovated ticket office. (Photo by Don Silverek.)

Mayor Schuyler Jeffries, at left, donned a hard hat and climbed aboard a crane for an aerial view of the 1982 renovation of Fourth Street between B and D Streets. The remodel included wide sidewalks for café outdoor seating and ended at B Street with the new downtown mall, the Santa Rosa Plaza. (Courtesy of the Sonoma County Library.)

As the governmental county seat with a courthouse, state building, and federal building, Santa Rosa is a magnet for protests against local and international policy. Here activists Jacques Levy, Dian Hardy, and an unnamed colleague animating a large puppet rally the crowd to protest U.S. policy in Central America in 1985. (Photo by Simone Wilson.)

126

Protest took a pungent turn in 1985 when residents of the Russian River area complained about Santa Rosa's repeated sewage spills and discharges into the waterway. Guerneville resident Tom Lynch took his complaint directly to Santa Rosa government officials, using this tractor to deposit some waste in the form of manure on the steps of City Hall. The episode earned him the nickname "Manure Man" and prompted studies that eventually resulted in a sewage pipeline to the Geysers. (Photo by Simone Wilson.)

One of Santa Rosa's most famous houses, the McDonald Mansion on McDonald Avenue is now the centerpiece of the McDonald Historic Preservation District. More than 120 years after entrepreneur Mark McDonald created the most elegant neighborhood in town, the Santa Rosa city council granted legal status to the district of heritage homes, assuring its preservation for future Santa Rosans. Other historic districts include the Cherry Street Preservation District, which boasts the highest concentration of 19th-century homes; St. Rose District, encompassing St. Rose Church and School as well as homes on Fifth through Seventh Streets; and Railroad Square District. (Courtesy of the Sonoma County Library.)

Commercial photographer Don Meacham (left) worked in Santa Rosa and in the 1950s and 1960s snapped many of this book's photographs, including shots of Hugh Codding, Montgomery Village, and the cover photo. Meacham, who now lives in Ferndale, graciously donated his photographs to the Sonoma County Historical Society, which in turn placed them with the Sonoma County Library, so that the public could enjoy them. (Courtesy of the Sonoma County Library.)